A SLAP IN THE FACE!

FUTURISTS IN RUSSIA

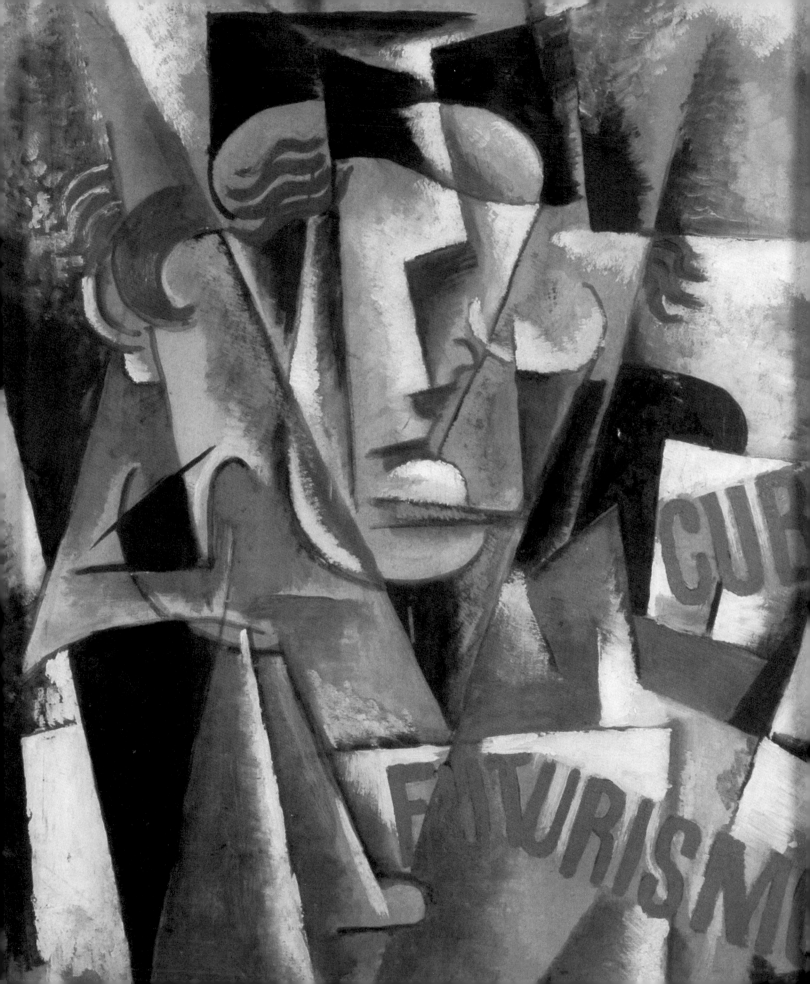

A Slap in the Face!

Futurists in Russia

John Milner

Estorick Collection of Modern Italian Art
Hatton Gallery
Philip Wilson Publishers

Published on the occasion of the exhibition:
A Slap in the Face! Futurists in Russia

28 March–10 June 2007
Estorick Collection of Modern Italian Art
39a Canonbury Square
London N1 2AN

23 June–18 August 2007
Hatton Gallery
Newcastle University
Newcastle upon Tyne NE1 7RU

Exhibition curated by John Milner

Exhibition organized by the Estorick Collection
Roberta Cremoncini
Christopher Adams

© Estorick Collection of Modern Italian Art 2007

First published in 2007 by Philip Wilson Publishers
109 Drysdale Street, The Timber Yard, London N1 6ND
www.philip-wilson.co.uk

Distributed throughout the world (excluding North America) by
I.B. Tauris & Co Ltd, 6 Salem Road, London W2 4BU

Distributed in North America by Palgrave Macmillan, a division of
St. Martin's Press, 175 Fifth Avenue
New York, NY 10010

ISBN: 978 0 85667 638 3 (hardback)
ISBN: 978 0 85667 639 0 (paperback)

Designed by Caroline and Roger Hillier, The Old Chapel Graphic Design

Printed and bound by Everbest, China

Front cover: Olga Rozanova, *Explosion in a Trunk* from *Universal War*
Olga Rozanova and Alexei Kruchenykh (detail, p.76 above)

Back cover: Olga Rozanova, *Heavy Gun* from *Universal War*
Olga Rozanova and Alexei Kruchenykh (detail, p.76 below)

Frontispiece: Lyubov Popova, *Portrait* (detail, p.53)

Page 8:
above left: Mikhail Larionov and Natalia Goncharova in a still from the film *Drama in the Futurists' Cabaret No. 13*, 1914
above right: Mikhail Larionov painting his face, 1913
below left: The futurist Vladimir Mayakovsky, Kazan, 1914
below right: David Burliuk with painted face, 1914

ACKNOWLEDGEMENTS

Our thanks are owed to the following institutions and individuals for their much appreciated help in the realization of this exhibition:

The British Library, London (Peter Hellyer, Barbara O'Connor, Robert Davies); Centre Pompidou, Paris (Alfred Pacquement); Dessau Trust; Galerie Orlando, Zurich (Susanne Orlando); Grosvenor Gallery, London (Ray Perman, Conor Macklin); Hatton Gallery, Newcastle upon Tyne (Liz Ritson and all at the gallery); Museo Thyssen-Bornemisza, Madrid (Tomàs Llorens, Guillermo Solana); Scottish National Gallery of Modern Art, Edinburgh (Richard Calvocoressi, Patrick Elliott); State Museum of Contemporary Art – The G. Costakis Collection, Thessaloniki (George V. Tsaras, Miltiadis Papanikolaou, Olga Fota); The State Russian Museum, St. Petersburg (Yelena Petrova); State Tretyakov Gallery, Moscow (Galina Gubanova, Lidia Iovleva); Tate, London (Matthew Gale); Thyssen-Bornemisza Collections, Zurich (Maria de Peverelli, Denise Morax); Van Abbemuseum, Eindhoven (Charles Esche, Christiane Berndes); V&A Theatre Museum, London (Andrew Kirk); Victoria and Albert Museum, London (Rebecca Wallace, Liz Wilkinson, Juliet Ceresole, David Packer)

Rosamund Bartlett; Lutz Becker; James Butterwick; Sarah Dadswell, University of Exeter; Lady Elizabeth Davenport; Jon P. and Pamela J. Dorsey; Catja Gaebel; Christopher Green, Courtauld Institute of Art; Nina Gurianova, North Western University, Illinois; Nikita D. Lobanov-Rostovsky; Nina Lobanov-Rostovsky; Henry Milner, Pipers, London; Anthony Parton, University of Durham; Elizabeth Philips; Massimo Prelz; Avril Pyman, University of Durham; Patricia Railing, Artists Bookworks; Maria Starkova; Margareta Stjernström; Paul Thomas; Yelena Walker, Lucy Whetstone

And all those who have chosen to remain anonymous.

CONTENTS

FOREWORDS

'On May Day of last year, the Russian cities were decorated with futurist paintings. Lenin's trains were decorated on the outside with coloured dynamic forms very like those of Boccioni, Balla and Russolo. This does honour to Lenin and cheers us like one of our own victories.' – F.T. Marinetti, 1920

Filippo Tommaso Marinetti visited Russia in 1914 to spread the futurist gospel, but on the whole the Russian avant-garde fought for a very different future from the one imagined by Marinetti and his group. In particular, many Russian futurists adhered to communism and participated in the revolution that intended to renew the foundations of Russia and indeed the world, contributing with their creativity to the building of the society of the future. Most of the Russian futurists aligned themselves with the Bolsheviks and proletarian internationalism, moving with Lenin from the imperialist war to fight the October Revolution.

But how can results so different be possible? For which 'future' were the Italians and Russians fighting? Initially, the generalised opposition of the young generations was to the past and the gap was between those who wanted to fight – even with physical violence – against those on the other side who remained stuck in the past, paralysed by inertia and fear. However, it quickly became evident that this kind of opposition was not enough – one had to choose sides: nationalist war or international revolution.

Futurism was based on simple statements which seem very clear because extreme, but they would soon show many contradictions. Futurism was born with clear sympathies for socialism and anarchism and broadly welcomed anybody who fought to subvert the status quo – an attitude that was thus applicable to very different realities from the Italian one. Marinetti stated that 'every nation has its own form of *passéisme* to overthrow: we [Italians] are not Bolsheviks because we have a different revolution to carry out'. In a later text he commented 'I am delighted to learn that the Russian futurists are all Bolsheviks and that for a while futurism was the official Russian art ... All the futurisms of the world are children of Italian futurism created by us […]. All futurist movements are nevertheless autonomous.'

A Slap in the Face! Futurists in Russia continues the Estorick Collection's ongoing efforts to situate our permanent collection of twentieth-century Italian works in a wider context, not only within Italian art but also a wider, international dimension. This exhibition concerning the influences of Italian futurism on the Russian avant-garde follows other very successful shows on vorticism and European avant-garde graphics.

This exhibition would not have been possible without the enthusiasm and dedication of many people, and I would like to thank firstly John Milner, the curator of the exhibition who has indefatigably worked on this project for over three years and has been involved in every stage to produce such a compelling show. We are delighted that the exhibition will travel to the Hatton Gallery in Newcastle after the London showing and we would like to take this opportunity to thank them for their assistance in the realization of this project. We are naturally indebted to all lenders both private and public who have generously agreed to lend their works for this show. I would also like to thank my staff here at the Estorick Collection and in particular Chris Adams who has dedicated countless hours to this project to make sure that everything was perfect from every point of view. I would also like to thank Philip Wilson Publishers with their staff and designers for producing such a handsome publication. My gratitude goes to Lutz Becker for his constant support and advice. Finally, a particular mention must go to Thomas Hunt, who has been part of this exhibition since the very first day.

Roberta Cremoncini, Director, Estorick Collection

The Hatton Gallery is committed to bringing innovative new exhibitions to a North East audience, a commitment that leads to such exciting collaborative opportunities as *A Slap in the Face! Futurists in Russia*. The Hatton's involvement in this exhibition arose from our relationship with Professor John Milner, to whom we extend our warmest thanks for his continued support, and led to a new relationship with the Estorick Collection. It has been a pleasure to work with Roberta Cremoncini and Christopher Adams, to whom we are indebted for their hard work and dedication. The Hatton Gallery would also like to acknowledge the support of Newcastle University, the AHRC and the Northern Rock Foundation.

Liz Ritson, Acting Curator, Hatton Gallery

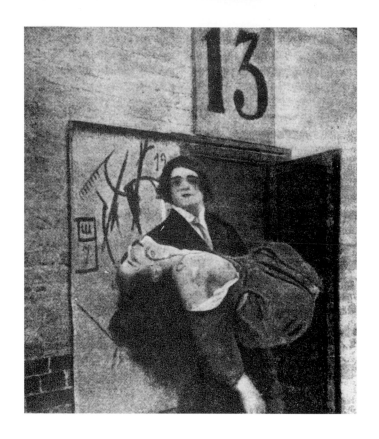

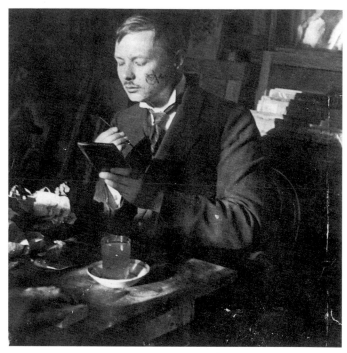

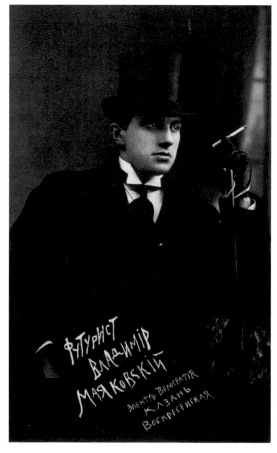

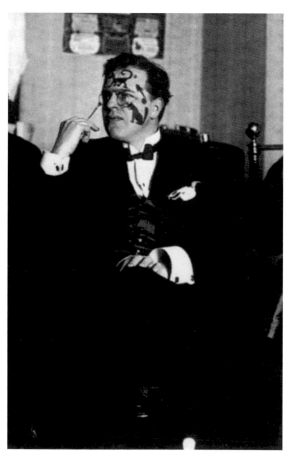

ZANG! ZAUM!

When Filippo Tommaso Marinetti stepped off the train in Moscow on 26 January 1914, he was tired and cold. He had travelled from Milan to Moscow in mid-winter and was half expecting a rough reception. The newspaper *Rannee Utro* (Early Morning) had announced his imminent arrival: 'He is already the centre of attention. The Moscow futurists are preparing a magnificent welcome for the father of futurism with rotten eggs and sour milk.'[1]

Marinetti wanted to spread the futurist movement across Europe and personally lead futurism wherever its ideas and works might flourish. He loved acrimonious debate. From their initiation in 1909 futurists in Italy had promoted speed, energy and fighting. No futurist evening in Milan or Bologna was complete without aggression between performers and the audience. This made Marinetti a gift to the press, and his notoriety had reached Russia. He had opponents there but also admirers who invited him to Moscow and St. Petersburg.

The Russian artists and writers who did not welcome his visit wanted to confront him and spoil his colonizing ambitions. They considered Russian futurism an independent and antagonistic movement. Their manifesto, *A Slap in the Face of Public Taste,*[2] was published after the Italians' *Founding Manifesto*, but their activities were underway by 1910. Their futurism was independent and distinct from that of the Italians.

PROLOGUE

Russian artists had long exhibited in Italy. They contributed to the Venice Biennale, for example, where the painter Filip Malyavin (Philippe Maliavine) had some success in 1901 with images of dynamic dancing peasants, depicted with energetic sweeps of red paint. He exhibited *Il Riso* (The Laugh), a familiar theme in Italian art at the turn of the century.[3] The sculptor Medardo Rosso was making haunting plaster and wax studies of laughter. Later the Italian futurist painter Umberto Boccioni was to use this theme for a large canvas in which fragmented light and space echoed the energy of laughter.

Boccioni had Russian friends in Paris, and he may have seen Sergei Diaghilev's exhibition of Russian art at the 1906 Salon d'automne, his first attempt to present Russian culture to Paris at a time when Parisian art was increasingly exhibited and collected in Russia. Diaghilev took the young painters Pavel Kuznetsov and Mikhail Larionov to hang the exhibition.[4] Soon Larionov was a leader of the Russian futurists and Diaghilev the great impresario of the Ballets Russes.

Boccioni made an expedition to Russia via Warsaw and Smolensk in August 1906,[5] to visit his friend Petr Popov (Pietro Popoff) at his estate near Tsaritsyn on the Volga.[6] Boccioni also explored Mongol Buddhist Kalmyk settlements to the east. He returned via Moscow and St. Petersburg. By November 1906 he was back in Warsaw and on his way to Vienna, travelling into Italy via Udine to Padua.[7]

Boccioni began a divisionist portrait of Sofia Germanovna Popova under the enthusiastic encouragement of the Popov family.[8] They had a particular interest in the painters of the World of Art group (*Mir Iskusstva*) gathered around Diaghilev. Through them Boccioni became aware of the Golden Fleece (*Zolotoe Runo*) group, including Mstislav Dobuzhinsky, Pavel Kuznetsov and Martiros Saryan,[9] and he maintained these contacts after his return from Russia.[10]

Diaghilev organized the Russian display in Room 32 at the VII Venice Biennale (22 April – 31 October 1907)[11] including a decorative panel by Pavel Kuznetsov, Larionov's painting *Acacias in Spring* and paintings by Malyavin. Here too were canvases by Nicolas Roerich (Nikolai Rerikh), a painter, stage designer and archeologist of ancient Russian sites, who exhibited *Ancient Town* and *Slavs on the Bank of the Dneiper River*, evocations of an ancient, primeval and mythical Russia, a vision later adopted by some Russian futurists;[12] the evocation of a mythical ancient Russia was not incompatible with vigorous innovation.[13]

Boccioni was living in Venice and probably saw the exhibition.[14]

He was working on etchings and paintings that brought a modern eye to the old canals and palaces, adapting new techniques to suggest the scintillation of the city.[15] Boccioni faced the past with enthusiasm, but was not drawn into the depiction of historical myth.

When Marinetti, the poet and leader of the movement, launched futurism in Italy on 20 February 1909, he condemned a worship of the past that induced immobility and sleep. Only by embracing the future would Italy awake from centuries of slumber. The sheer energy of factories, ships, cars and even war would revive Italy.

Marinetti's manifesto was reported in Russian newspapers barely a week after its launch.[16] As painters began to gather around him, Giacomo Balla, Umberto Boccioni, Carlo Carrà, Luigi Russolo and Gino Severini launched their own *Technical Manifesto of Futurist Painting*. This too found a rapid response in the Russian press when the futurist Paolo Buzzi published his 'Letters from Italy' in the journal *Apollon*.[17]

PREWAR

Within a year equally provocative, outspoken, assertive and inventive Russian artists and writers had formed a group that they too called *futurist*.

These Russian groups had a different attitude to the past, a vision of a mythical and timeless Russia, of Scythian settlements on the Black Sea, Vikings on the Volga, Siberian shamanism and Asian invasions. This was the opposite of Marinetti's 'chattering flight of aeroplanes' and 'new beauty of speed'. But the vast Russian territories were agrarian and substantially Asian with no indigenous classical past against which to rebel. Many Russians were wary of westernization, so Russian futurists were wary of Italian futurists.

When Russian futurist artists and writers gathered in 1910 around the painter David Burliuk as the 'father of Russian futurism', and around the recklessly inventive and imaginative poet Velimir Khlebnikov, they wanted a movement built on distinctly Russian roots. They questioned the need to address the innovations of Western Europe. This was an issue that each creative individual needed to resolve.

Some Russian futurists welcomed Marinetti enthusiastically; others rejected his leadership of international futurism. Boccioni,

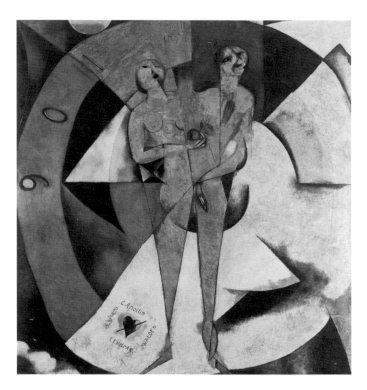

Marc Chagall
Homage to Apollinaire
1911
oil with gold and silver powder on canvas
200 x 189.5 cm
Stedelijk van Abbemuseum, Eindhoven

who had visited Russia, may have understood this better than Marinetti. Every Russian artist and writer addressed issues of East or West, of Europe or Asia, and the need for identity in a shifting balance of cultural forces, so Russian futurists looked back as well as forward, and ancient myths were part of their future.

Futurists in Russia were provocative, public, dynamic, physical, innovative and iconoclastic – but they often combined this with images of ancient times.[18] By 1911 the Russian peasant, an image of basic, unchanging identity, featured in innovative futurist works, a figure of the future as well as the past. When Roerich, for example, worked with the composer Igor Stravinsky, studying peasant art and costumes [p.96], they were planning the most dynamic, revolutionary as well as ancient, iconoclastic and rural ballet, *The Rite of Spring*, which premiered to uproar in Paris in 1913.[19]

Diaghilev took Russia to Paris, producing *Prince Igor* there in May 1909 and *Petrushka* in June 1911. His painters Leon Bakst, Alexandre Benois and Valentin Serov, were regular visitors.

Russian collectors Sergei Shchukin and Ivan Morozov competed with American buyers for the latest and most daring works of Monet, Gauguin, Matisse and Picasso. Russian money brought the painter–theorist Maurice Denis to Moscow in 1909 and Matisse in 1911, both for major commissions. In these collections Russian painters could study the latest Parisian art.

Marc Chagall arrived in Paris in 1911 and took his fascination with Russian Jewish folklore with him. In the cramped circular studio-block La Ruche in Montparnasse he was the neighbour of Modigliani, and a friend of Robert and Sonia Delaunay (née Terk). He consumed Parisian art with a voracious appetite, bringing Russian, Jewish and Parisian art into a fantastic synthesis. In their different ways both Diaghilev and Chagall brought Russia to Paris. The faceted forms of cubist paintings are transformed by Chagall's vigour and imaginative richness. While major canvases pay homage to Delaunay and to the poets Guillaume Apollinaire and Blaise Cendrars, they keep a persistent and powerful Russian aspect. In *Homage to Apollinaire* of 1911–12 [p.10], Chagall presents a great circle, reminiscent of Delaunay's disk paintings, but here fragmentary numerals indicate 9, 10, 11, making this disk a clock face. Clouds set this clock in the sky to indicate the association of the sun with the measurement of days and years. Chagall's gold and silver paint suggest an alchemical and mystical dimension to the painting, confirmed by the biblical Adam and Eve at the moment of partition. Chagall shows time emerge from measureless eternity, as described in Genesis. In a cartouche with an arrowed heart are the names Herwarth Walden (director of the Sturm Gallery in Berlin), Apollinaire (poet and critic), Blaise Cendrars (poet) and Canudo (writer), from whose names Chagall conjures the ancient four elements of earth (Walden, *Wälder*, woods), air (Apollinaire), fire (Cendrars, *cendres*) and water (Canudo, *eau*). So Chagall developed the theme of cosmological time, a concept far removed from the rush of the aeroplane, tramcar or racing automobile promoted by Marinetti.

On 5 February 1912 the Italian futurists opened their exhibition at the Galerie Bernheim-Jeune in Paris.[20] Three years after the *Founding Manifesto* they adapted the crystalline faceting of cubism. They too turned to the international centre of art for status and recognition. Only one day after the futurist exhibition closed in Paris, David Burliuk addressed the subject several thousand miles away in a discussion organized by the Knave of Diamonds group at the Moscow Polytechnic Institute.[21]

By 1912 the Italians were depicting simultaneous impressions – including sounds, memories and movements – by repeatedly overlapping transparent images. Balla's painting of *The Hand of the Violinist*, 1912 [p.48], shows sequential movement and implies sound. *Synthesis of a Café Concert* by Carlo Carrà [p.13] evokes music with the scrolled neck of a cello and the staves of a music manuscript floating above it. A male figure in a jacket and shirt is at the centre of this explosive composition. The figure is embedded in a deluge of sensations, sounds, music and movement.

Russian futurist artists and poets collaborated on many radical and anarchic books in 1912–13, including the seminal *Worldbackwards* (*Mirskontsa*) published in 1912. Larionov's lithographic illustrations pay homage to Carrà and Boccioni. Larionov's *Street Noises* [p.11] recalls Boccioni's *Sounds of the*

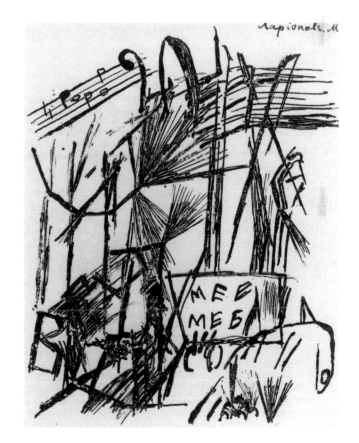

Mikhail Larionov
Street Noises
Illustration for *Worldbackwards*
1912
lithograph
18.6 x 15 cm
Private collection

Street Penetrate the House. The lithograph also reproduces the same fragment of music, its notes and staves in the same position, as in Carrà's drawing. Larionov drew other images using explosive radiating lines or forms that overlap. These include posts, a telegraph pole and wires, a street lamp and the simplified image of a horse heaving a large cart inscribed with lettering. The high view of the approaching tram featured in Boccioni's *The Forces of a Street*. Larionov's radiating lines represent street lights as Boccioni showed them and the circular form echoes the streetcar's headlight in Boccioni's painting. Larionov had studied Italian futurist works in detail.

These images show the ordinary life of the urban boulevard, with traffic and people going about their business. This is a familiar theme from impressionism to the Italian futurists. There is no sign here of ancient Russia, but in 1913 a new group gathered around the painter Natalia Goncharova and her partner Larionov. They adopted the name Donkey's Tail (*Oslinnyy khvost*) as they abandoned the Knave of Diamonds exhibitions to escape their excessive deference to western art.

This profusion of groups, according to David Burliuk, 'did not mean mutual exclusion. Everything here blended into a wild wind of disintegrating solar spectra, into the virgin chaos of colours, which gave back to the eye a barbarous sharpness of vision, and with it an inexhaustible source of forgotten joys'.[22] Goncharova and Larionov's work could not adequately be explained in terms of Italian futurism.[23]

Without the poet Velimir Khlebnikov Russian futurism could scarcely have existed. This quiet, inventive and unique poet had an immense impact on Russian art and poetry. The evolution of language through time was one of his central concerns. He traced the roots of Slavic words, isolated the elements that defined their meaning and manipulated this to make poetry. His new words had the spirit of ancient Russian. This he called *zaum* (pronounced as two syllables: *za-um*). As *za* means beyond, and *um* is mind or intelligence, the new word *zaum* means 'beyond sense', a language both old and new, distilled to a Slavic essence and stripped of Western European accretions. This was contemporary with Marinetti's *Words in Freedom* ('Parole in Libertà') [p.66], which imitated sounds and spread words across the page in changing fonts and sizes. But Khlebnikov's aims were not mechanistic imitations of trains, gunfire, aeroplanes and explosions.

Khlebnikov's poetry preferred birdsong to mechanical noise. It explored the shapes of individual letters, relating verbal textures to

the tactile and visual textures of artists. He incorporated numbers and calculations. He observed the migration of words, carrying cultural identities across a world fraught with the conflicts of great cultures. Language, in this view, was an active element in the colliding cultures of his day, in the decay of the Ottoman Empire, the Balkan wars, the crumbling Austro-Hungarian Empire. Language, identity and war were interlinked. Khlebnikov studied their rhythms both in poetry and in battles. He linked past and future. Some texts were predictions and friends took his prophetic role seriously. This enigmatic, modest and ambitious man, this nervously reclusive poet, styled himself Velimir I, President of the Terrestrial Globe, King of Time. He offered a sharp contrast to Marinetti in his personality, his poetry and in his ideas.

As Khlebnikov also studied the celestial movements of planets in the turning dome of stars of the night sky, he was aware of the solar eclipse of 17 April 1912. The moon's eclipse of the sun that day was visible as a partial eclipse in both St. Petersburg and Moscow.[24] It had an impact on Russian futurists and was linked to experiments with words in a way that only Khlebnikov could have devised or initiated. The partial eclipse became the subject of several paintings by Kazimir Malevich, Vasili Kandinsky and others, as well as the futurist poet Alexei Kruchenykh who staged his futurist opera *Victory over the Sun* in December 1913 in St. Petersburg.

By then the young poet and painter Vladimir Mayakovsky had joined the futurists in Russia. When he later recalled their collaboration he made a deliberate play on their names, carefully using the word eclipse: 'at the end of 1912 together with Khlebnikov, David Burliuk and Alexei Kruchenykh, the declaration manifesto *A Slap in the Face of Public Taste* was written. Khlebnikov was in Moscow. Stormy David [i.e. David Burliuk, whose name relates to the verb *burlit'*, to storm] eclipsed his quiet geniality for me. Here

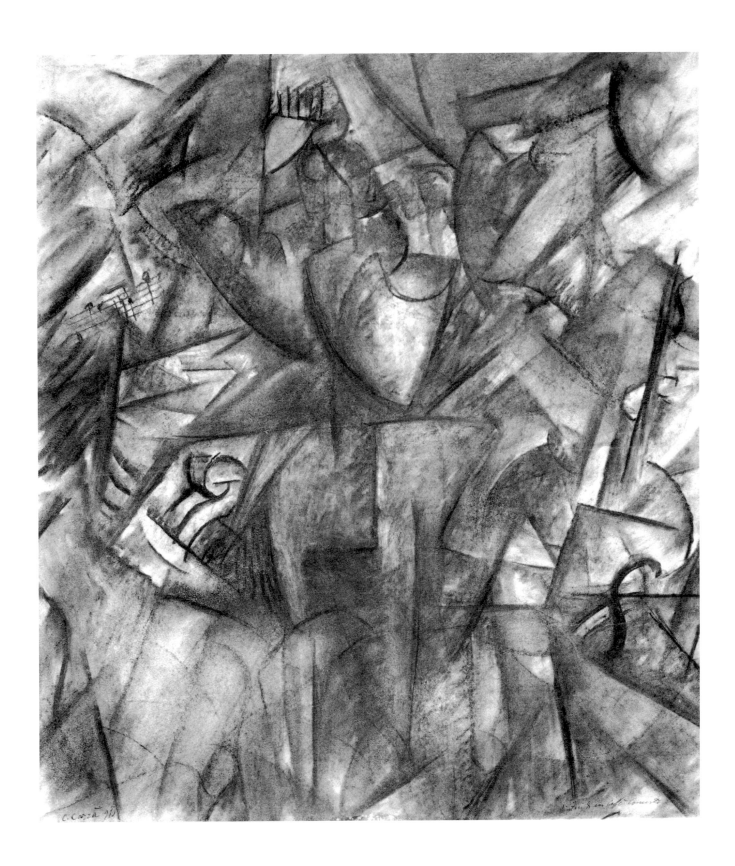

followed the Futurist Jesuit of the word Kruchenykh [whose name is related to the word *krutoy*, severe, *kruche*, more severe].'[25]

Chagall too juxtaposed memories and vision. His *Self Portrait with Seven Fingers* [p.14] illustrates the dilemma. The elegantly dressed painter sits at his easel, a flower in his buttonhole, a colourful tie and curly hair, a man about town, with the Eiffel Tower and the boulevards of Paris through his window. He works so fast that he must have seven fingers. This is comparable to the hand of Giacomo Balla's violinist [p.48], but here there is also a fantastic scene involving a flying peasant woman. In his dreams and in imagination Chagall was in Russia. The painting within the painting, *To Russia, Asses and Others*, perhaps refers to the Donkey's Tail group in Moscow, newly formed by Goncharova and Larionov, eager to turn their backs on the dominant art of the West.

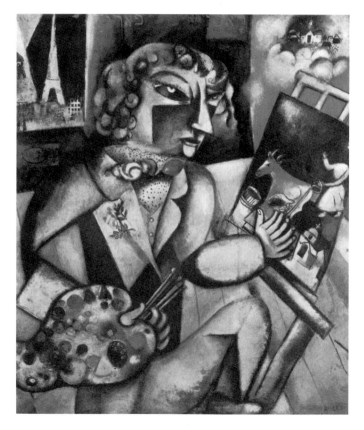

Marc Chagall
Self Portrait with Seven Fingers
1912–13
oil on canvas
128.1 x 107 cm
Stedelijk Museum, Amsterdam

Painting 'states of mind' was a feature of Italian futurism. Boccioni called his great triptych of 1912 *States of Mind*. His image of longing and departure is not so remote from Chagall's haunting dream of Russia. Chagall turned his back on modern Paris for his imaginary journey to Russia. The Russian response to Italian futurism was complicated by different aims and identities. Both showed a national pride, for example, but to different cultures and in different ways.

When the Union of Youth exhibition society in St. Petersburg published 'The Exhibitors to the Public: A Manifesto of Futurist Painting' in their periodical in June 1912,[26] Russian futurists were quick to respond. David Burliuk energetically drummed up support, approaching the Knave of Diamonds in Moscow and the Union of Youth in St. Petersburg for support to launch a Russian futurist anthology of manifestos. He wrote urgently to Benedikt Livshits: 'you have to send me an article at once, in any form you like. Be our Marinetti. If you are afraid to sign it, I will sign it myself.'[27] David Burliuk wanted to organize a group of futurists into a fighting force equal and opposite to the Italians. 'Storming' Burliuk saw that Russian futurists had to distinguish and assert themselves. They too brought poets, painters and musicians together to make radical works. Skill with publicity, coordinated flair, aggression and noise could promote their own views and their distinct concepts of space, time and *zaum* creativity.

The manifesto by David Burliuk, Alexander Kruchenykh, Vladimir Mayakovsky and Viktor (Velimir) Khlebnikov appeared in *A Slap in the Face of Public Taste*.[28] Printed in Moscow in December 1912 in only 600 copies, and officially passed by the censor in January 1913, its grey and brown paper was covered in sacking, the starkest contrast to the luxurious covers of publications from the World of Art or Golden Fleece. Assertive crudeness was a hallmark of Russian futurist work, debunking academic conventions for radical new creativity.

'We alone are the image of our time,' they declared, 'the horn of time blows on us in the art of words. The past is narrow. The Academy and Pushkin are less intelligible than hieroglyphics. Pushkin, Dostoevsky, Tolstoy must be thrown overboard from the steamer of The Present Time.'[29] Poets were instructed: '1. To enlarge the *volume* of the poet's vocabulary by words arbitrary and derivative. 2. To reject the invincible hatred for the language that existed before them. 3. To wrest with horror from their proud foreheads the wreath of penny glory woven out of bath birch twigs. 4. To stand on the rock of the word "we" in the midst of a sea of

catcalls and outrage. And if, *for the time being*, the filthy marks of your "common-sense" and "good taste" have remained in our lines, nevertheless, *for the first time*, the Lightning of the New Future Beauty of the Self-Sufficient Word is already flashing on them.[30]

They asserted the Word revealed by Khlebnikov. Their 'steamer' may have recalled the 'steamers sniffing the horizon' in Marinetti's *Founding Manifesto* of 1909, but in Russia futurist poetry lay in the most radical idea of verbal material extended like sails in time and space, in which the present moment is no more than a cross-section of its existence. The word, for Khlebnikov, is part of a continuous history of verbal material in flux, affected by the rhythmic ripples of historical events.

Khlebnikov's concentration on Slavic culture provided a strong national focus but did not travel well abroad. In his historical studies he focused on the clash of great cultures, of East versus West, on the Mongol invasions across Asia and on the Islamic, Turkic, Persian and Arabic influences on the south of Russia, which revealed cultural fault lines still visible in the First Balkan War of 1912, when Bulgarians besieged the Turks at Adrianople. Khlebnikov studied these battles as Slavonic Serbia and Bulgaria (alongside Greece and Montenegro) fought the Turks. These Turks appear in Khlebnikov's contemporary verses and in the graphic and theatrical work of Tatlin and Malevich in 1912–14.

Among the signatories of *A Slap in the Face of Public Taste*, Khlebnikov and Kruchenykh were central and dedicated experimental writers. Their 'New Beauty of the Self Sufficient Word' distanced them from the 'new beauty of speed' celebrated by Marinetti. In Russia futurist painters and poets made books together and a new fusion of verbal and visual material was forged.

The book *Worldbackwards* with poems by Kruchenykh and Khlebnikov appeared just before the *Slap* manifesto, its cover decorated with cut-paper collages, different on every copy, created by Natalia Goncharova.[31] The poems, printed by stencil or even potato-cut, escaped conventional orthography and spread around the page. These radical books were the subversive, beautiful and problematic outcome of collaborating poets and painters, and almost all stressed hand-production. They were not mechanistic.

Kruchenykh collaborated with Goncharova on *A Game in Hell* [p.67], with Larionov on *Old Time Love* and with Goncharova, Larionov, Tatlin and Rogovin together on *Worldbackwards.*

Kruchenykh also worked with Goncharova on *Hermits* and with Larionov on *Half-Alive* and *Pomade* [p.69]. But he worked most with the brilliant futurist painter and graphic artist Olga Rozanova. Together they produced *A Forest Rapidly* as well as *Explodity* [p.71] and *Let's Grumble* [p.70]. David Burliuk had impressed her with his missionary zeal. He encouraged her and she attended his lectures. She became a central and powerful futurist.

When the Union of Youth exhibition opened on 4 December 1912 in St. Petersburg (running until 10 January 1913), Rozanova exhibited eleven works alongside the Burliuk brothers, Goncharova and Larionov, Malevich, Matiushin, Mayakovsky, Tatlin and others. Khlebnikov was their main inspiration. David Burliuk drew the different elements together. Mayakovsky and Kruchenykh became assertive and provocative performers with theatrical ambition and brilliance. Goncharova, Larionov, Rozanova and Malevich became in 1913 its most active and prolific core of painters.

Occasionally they did recall Italian futurist precedents. In the book *A Trap for Judges II* in 1913, Burliuk, Mayakovsky, Khlebnikov, Kruchenykh and others declared that 'We qualify nouns not through adjectives... but also through other parts of speech, and through particular letters and numbers... We have annihilated punctuation marks.' This is close to Marinetti's syntax. But they asserted the word: 'We regard the word as the creator of myth; the word, dying, gives birth to myth, and the other way round,' and the impact of this on painters was enormous.[32]

Larionov's *Soldier on a Horse* [p.56] (Tate) looks like a childish image of a toy. Larionov admired children's drawings, and even exhibited them alongside his own works. He also admired other forms of informal, untutored drawing and painting, including signboards and graffiti. All this is evident here, and it might be tempting to describe Larionov as a naïve artist. In reality he was well travelled, thoroughly taught, well read and intelligent. His painting reflects genuine interests deliberately and intelligently adopted. Much the same image, for example, was used to depict a running horse in the heroic images of Russian folk prints and *lubki*, with two of the horse's legs raised woodenly off the ground, just as Larionov has here. *Lubok* prints were often decorative, with shifts of scale, flattened space and lettering. *Lubki* often contain archaic Russian lettering and Larionov here has painted the letter Б, using the form like a circle with horns. Larionov is deliberately being archaic. The бе (*be*) is from бегать (*begat'*), to run, while the ск (*sk*) is from скачка (*skachka*), horserace, or from скачок (*skachok*), a jump or bound. It might also evoke сказка (*skazka*),

a story. The resulting беск (*besk*) is a new word for the running jump that we see in the painting.

This fits well with Khlebnikov's ideas of word-roots and the meanings they carry. In Moscow in October 1913 he and Kruchenykh published *The Word as Such* in five hundred copies, with illustrations by Malevich and Rozanova. In it was inserted *The Declaration of the Word as Such*, dated St. Petersburg, 10 April 1913, by Kruchenykh and the painter Kulbin.

In other paintings of 1912 Larionov pursued rural and primitive themes, painted with crudely sensual and powerful images of the seasons. *Spring* [p.59], a canvas of 1912, is a half-length of a bland, calm and smiling woman of vast proportions and a thick neck. Her breasts are high and exposed. Her hair hangs to one side and a ring dangles from each ear. This could serve as a sign for a bathhouse. Chagall, Larionov, Goncharova and Malevich all admired sign-painters' work, but here Larionov presents an image of fecundity, with a bird, flowers and a pig assembled around the great face, which is grotesque, beautiful, iconic and timeless. Across her hangs the word Весна (*Vesna*, Spring), like a saint's name on an icon, or a shop's name on a sign.

Larionov made personifications of all of the seasons in 1912–13. In *Autumn* [p.16], birds dive down to give a woman grapes, a man and a woman collect the vine harvest and there are flagons and containers for the wine. Each panel carries homage to its season. In *Autumn* this reads 'Happy Autumn shining like gold with ripening grapes and intoxicating wine.' The effect is pagan, an archaic signboard from the vineyards of the south where Larionov and Burliuk had grown up, and where they now revived the myths of ancient Scythia. There are no speeding automobiles in this calendar, where the seasons and the zodiac determine human behaviour.

Just as Khlebnikov sought Russian identity in verbal roots, so Larionov sought it in archaic imagery of land and people. Goncharova similarly painted the standing stone figures of Siberia, one of which now lies on Khlebnikov's tomb in the Novodeivichy Monastery, Moscow. Larionov's timeless figures inhabit a number of his paintings and studies in 1912–13, including his illustrations for *Pomade* (*Pomada*) [p.69], where they have ironic connotations of both prostitution and of Venus as the goddess of beauty.

This independent aspect of futurism is not mechanistic, has no sensation of speed, is essentially rural and invokes a mythical past far from the modern city. It produced Stravinsky's *The Rite of Spring*, which carried the vitality of Russian futurism to Paris

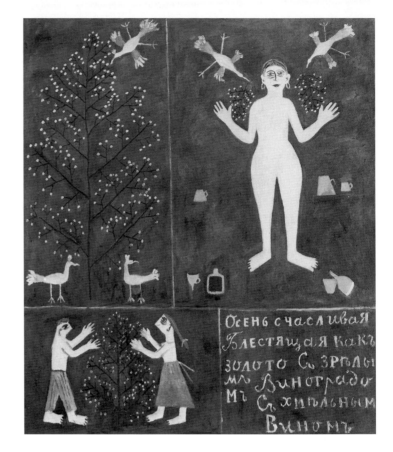

Mikhail Larionov
Autumn
1912–13
oil on canvas
136.5 x 113 cm
Centre Pompidou, Paris
Musée national d'art moderne/Centre de création industrielle

where it was seen as barbaric – just what its creators wanted.

The Rite of Spring's ferocity, power and complexity scandalized the audience with its raging energy, its noise and the stamping, orgiastic violence of its rhythms. Nothing in the Italian futurists' exhibition in Paris could match its pace and daring, or equal its force and dynamism. Ancient in its theme, it was also completely new.

Subtitled *Pictures from Pagan Russia*, *The Rite of Spring* opened at the Théâtre des Champs-Elysées, Paris, on 29 May 1913. In the first scene, set in the primeval forest, ancient dances, games and rites pay homage to the Earth. In part two a young woman is sacrificed to bring on the spring. Encircled by elders, she dances herself to death – in the face of howling protests from the infuriated audience.

All that was ancient in the theme was made furiously new.

It drove Russian futurism into the citadel of sophisticated, international art, and its 'barbarity' was the success of sophisticated people.

These futurists developed independent innovations, while meticulously exploring Italian futurism for their own ends.

ZAUM: LANGUAGE OF THE FUTURE

They launched a whole series of anarchic futurist books and debates in 1913. The Union of Youth in St. Petersburg organized lively discussions in the Troitsky Theatre on 23 March 1913, at which the composer–painter Mikhail Matiushin chaired the discussion 'On Modern Painting', with contributions from Olga Rozanova, Kazimir Malevich and David Burliuk. The next day 'On the Latest Russian Literature' had papers by Nikolai Burliuk, Vladimir Mayakovsky, Alexei Kruchenykh and again David Burliuk discussing the graphic and phonetic characteristics of words, in which 'consonants are the bearers of colour and notions of texture', and where 'vowels are time and space and the notion of the plane'.[33]

Kazimir Malevich, a protégé of Larionov and Goncharova in the Donkey's Tail group, collaborated on Russian futurist books in 1913. Olga Rozanova recalled Malevich vehemently contrasting the subservience to foreign influences in the Knave of Diamonds exhibition with the radical originality of the Donkey's Tail group. But Malevich embraced Italian futurists' ideas with enthusiasm. His lecture declared: 'You, driving along in your cabriolet, don't come chasing our futurist automobiles.'[34] He illustrated Marinetti's principles in a lithograph *Horse and Cab in Motion* [p.17 above] included in the book *The Three* (*Troe*) published in 1913. This graphically illustrates Malevich's adoption of splintered and repeated forms to depict sequential movements, as Boccioni and Carrà had used them. The wheels of the cab suggest movement with intersecting segments of circles, assembling sequential details to construct the image as a whole. The cab itself distinctly recalls the train in Boccioni's triptych *States of Mind* and the rhythmic movements of the horse are essentially those of Boccioni's painting *Elasticity*. This is a small-scale tribute from Malevich to his Italian contemporaries.

His major canvas *The Knifegrinder* [p.17 below] took up again the motif of whirling wheels. A treddle-operated flywheel spins the grinding wheel that sharpens knives. Malevich has used at least four

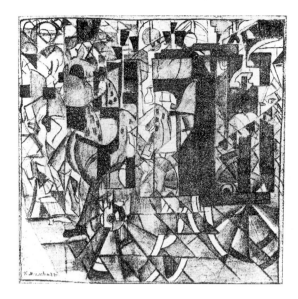

Kazimir Malevich
Horse and Cab in Motion, published in *The Three*
1913
letterpress
11 x 9.8 cm
Private collection

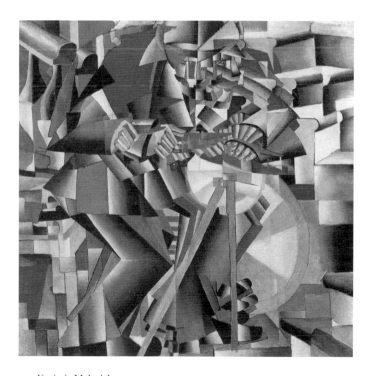

Kazimir Malevich
The Knifegrinder (Principle of Scintillation)
1912–13
oil on canvas
79.5 x 79.5 cm
Yale University Art Gallery, New Haven

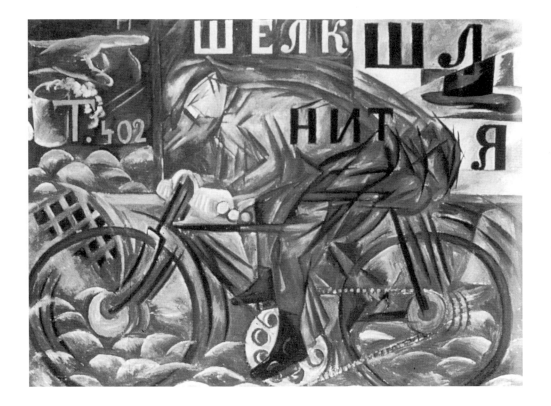

Natalia Goncharova
The Cyclist
1913
oil on canvas
78 x 105 cm
State Russian Museum
St. Petersburg

repeated images, overlapped, fragmented and intersecting, to depict moving forms. The shoulder and head judder almost uncontrollably. This compares closely with Gino Severini's dancers, and Malevich's subtitle *Principle of Scintillation* recalls Severini even more closely.

Malevich may have aspired to wider, international fame through futurism. His *Knifegrinder* suggests an awareness of Marcel Duchamp's *Nude Descending the Staircase*.[35] Malevich did not go to Paris, but his colleagues did, yet he exhibited at the Salon d'automne. Malevich had previously painted calendar themes, labours of the months, just as Goncharova and Larionov had. But with Goncharova's *Cyclist* [p.18], in which the figure and wheels are almost transparent, the Italians' 'principle of scintillation' was back, with Malevich following. They used identical strategies

to depict worker, machine and motion, and both adopted and transformed Italian futurist principles to do it.

In Larionov's lithograph *The City* [p.19 above left], a streetcar rolls along an avenue of lamp-posts and cables. Buildings either side lean in a crystalline canyon of forms derived from Carrà and Boccioni. A horse and carriage and a second horse labour along the street. The noise and bustle of the street is impressive. On a larger scale, Gino Severini's important *Boulevard* of 1913 is similarly illuminated by triangular prisms of lights beneath which the activity of the city street appears in shattered, geometrical forms where individual figures are embedded into the greater life of the city. Malevich, Goncharova and Larionov were independent and at the same time enthusiastic students of the Italian futurists.

In the boulevard scene published by Larionov in the book *Le*

Mikhail Larionov
The City
1912
transfer lithograph on postcard
9.5 x 14.2 cm
Reproduced in E. Ėganbyuri [Ilya Zdanevich]
Nataliya Goncharova Mikhail Larionov
(Moscow, 1913)

Mikhail Larionov
Illustration for *Le Futur*
1913
lithograph
15.5 x 19.9 cm

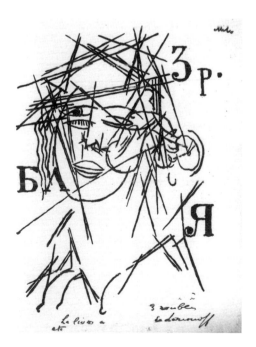

Mikhail Larionov
Illustration for *Le Futur*
1913
lithograph
19.9 x 15.5 cm

Futur (the title was in French) figures walk along the street [p.19 above right]. Below are a bicycle wheel and a horse's head. The female pedestrians have transparent clothes in this kaleidoscope of impressions, memories and imagination. There is physical activity in the boulevard and ceaseless movement of the viewer's awareness where sight and memory collide.

The bicycle image appears again in *Le Futur*, where it crosses the face of a woman [p.19 below]. The location of the bicycle image recalls the question asked in the *Manifesto of Futurist Painting*: 'Who has not seen the image of a horse running across the face of a woman seated opposite in an omnibus?' In Larionov's image it is the woman, the price and the bicycle. The lettering says *3р БЛ Я* (*3r BL YA*), fragments of *3 Рубля* (*3 Roubles*). This is a price, and БЛЯ can be part of БЛЯД (*blyad*), prostitute.

Boccioni's *Dynamism of a Cyclist* [p.21] is remarkably close to the bent figure in Larionov's illustration. Goncharova adopted the same pose in her *Cyclist* [p.18] painting of the same year. Boccioni's cyclist moves fastest. Goncharova's *Cyclist* bounces over the cobblestones, past signs advertising beer and hats. Goncharova includes the letters Л and Я, just as Larionov had, and the letter Я appears in the same form and position, but now part of the word ШЛЯПА (*shlyapa*, a hat) that goes with ШЕЛК (*sholk*, silk), the kind of silk hat worn by David Burliuk in futurist events.

Goncharova's painting *Linen* (Tate) of 1913 has letters ПРАЧЕ, a fragment of the word for laundry. She is inscribing her canvas like a signboard. The letters БОТ indicate РАБОТА (*rabota*, work). Masculine collars, cuffs and shirts are contrasted with the dress and lace. By inscribing the heavy iron with her initials НГ (*NG*) Goncharova shows who does the work. The shirt is marked ЛА (*LA*) for Larionov, to make a double portrait of their clothes ready for a futurist night out.

Their word games were as elaborate as anything by Duchamp. Eli Eganbyuri, author of the first book on Larionov and Goncharova, was futurist Ilya Zdanevich.[36] He produced the name Eganbyuri by writing his name in Russian, then reading as Latin script.

Imagery of the boulevard stood awkwardly beside archaic imagery. Larionov's lithograph *Lady in a Hat*, 1913, originally glued onto gold paper, is in itself a subject dear to Boccioni and Severini, though Larionov's reductive technique is daring in the extreme, depicting the woman in just five lines and her hat in ten. Severini's *Portrait of Mlle Susanne Meryen of the Variété* is comparably urbane, artificial and elegant.

The urbane outfits worn by Larionov, Goncharova, Zdanevich, Burliuk and Mayakovsky deliberately pushed elegance beyond the limit. It formed a sharp contrast to their wilder, unconventional paintings and poems. Burliuk carried a lorgnette, wore a vehemently striped waistcoat and carried a wooden spoon in his breast pocket. Mayakovsky's yellow waistcoat became synonymous with futurist events on Moscow's streets, as well as in the theatres and debating halls he used. If Larionov's *Seasons* were sophisticated when they appeared crude, then futurist sartorial style appeared sophisticated when actually they were playing rough. Larionov, Goncharova and Zdanevich began to paint words and images on their faces. David Burliuk, Mayakovsky and Kamensky adopted the technique to exasperate the public.

On 23 March 1913, Larionov organized a debate on 'The East, Nationality, and the West', to launch the futurist exhibition 'Target' (*Mishen*) due to open in Moscow the next day. Larionov spoke about his new style rayism, and Ilya Zdanevich lectured on 'The Futurism of Marinetti', arguing that modern clothes are more beautiful than the Venus de Milo.

In his rayist manifesto Larionov declared that 'the most amazing, the most modern doctrine of futurism can be transferred to Assyria or Babylon, while Assyria… can be brought to what is called our age…The futurist movement can only be regarded as an extra-temporal phenomenon.'[37] Larionov exhibited paintings alongside folk prints, Persian popular prints as well as Indian and Chinese art, seeking to distance himself from Italian futurists.

Larionov exhibited his *Seasons* paintings and rayist works at the 'Target' exhibition of 24 March–7 April 1913. With Goncharova, Larionov appeared at the head of this new group that offered itself as a target for public abuse. Malevich, Chagall and Zdanevich were the exhibitors. In addition *lubki* were shown, works by the Georgian sign painter Niko Pirosmanshvili, anonymous drawings and children's drawings. Under the slogan 'we aim towards the east', they sought out national art forms, mixed all styles, ancient and modern, and steered a path away from the Italians.

Rayists contemplated light reflected from every point on an object to produce beautifully crystalline paintings, of which Larionov's *Blue Rayism* [p.62] is a good example. But rayism did not wholly shake off the Parisian art world. Larionov's pamphlet on rayism, published in April 1913, included a discussion of Orphism and recent work by Robert and Sonia Delaunay. Still the Russians were on the whole less urban, as Goncharova's *The Forest* [p.97] of 1913 illustrates. Links remained. Larionov showed works at the First German Autumn Salon at the Berlin Sturm Gallery in 1913, and later at his 'Exhibition No. 4' in Moscow in 1914. Delaunay's disks were also at the Berlin Autumn Salon in September–December 1913, as was a wide range of paintings by cubists including Léger, by Blue Rider artists and Italian futurists, including Balla's *Dynamism of a Dog on a Leash*. Other exhibiting Russians included Larionov as well as the Burliuk brothers, Nikolai Kulbin, sculptor Alexander Archipenko, Marc Chagall and the Georgian painter Georgiy Yakulov.

But the Italian futurists had not been idle. Boccioni's spectacular sculpture exhibition opened in Paris in June 1913 and was almost certainly seen by the painter Lyubov Popova and her friends working in Paris. An article in *Apollon* magazine reviewed Boccioni's sculpture exhibition[38] and discussed the principles of dynamism expressed in musculature, especially in Boccioni's *Spiral*

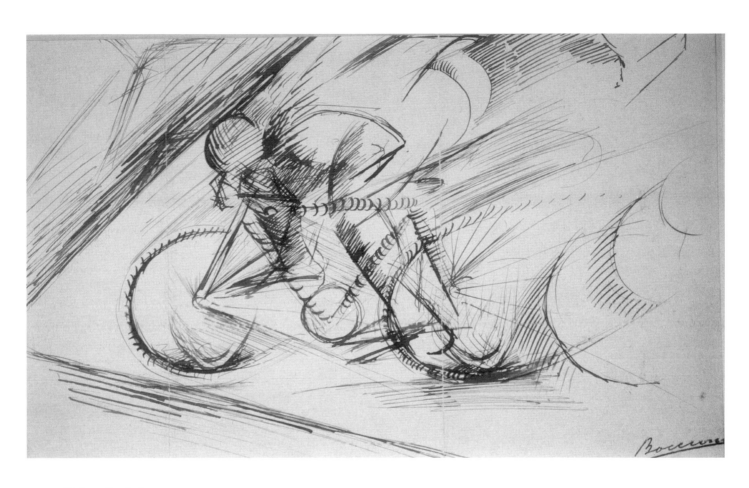

Umberto Boccioni
Dynamism of a Cyclist
1913
ink on paper
18 x 30 cm
Estorick Collection, London

Expansion of Muscles in Movement, and quoted Boccioni saying that it was fruitless to seek the figure's traditional lines, as here the figure was 'the centre of plastic movements in space'. He also discussed Boccioni's *Development of a Bottle in Space* to illustrate the Italian futurist idea of 'lines of force'. Boccioni and Marinetti meanwhile visited the studio of sculptor Alexander Archipenko, where Marinetti found that 'Slavic darkness meaningful for the synthesizing energy it reveals does not entirely please Boccioni', who found it 'archaic and barbaric'.[39] On 29 June 1913 Apollinaire published in Paris *The Futurist Anti-Tradition: Manifesto–Synthesis*, discussing Picasso, Duchamp, the major Italian futurists, but also Archipenko, Stravinsky and Kandinsky. Another enthusiast of Italian futurism, the critic Genrikh Tasteven, decided to invite Marinetti to Russia, perhaps with encouragement from Nikolai Kulbin.

The Italians set a ferocious pace of innovation, leaving other futurists to accept their challenge or withdraw. The Russians' material study of the Russian word could scarcely be translated and was almost impossible to export. In this situation face-painting was distinctive. Larionov appeared with a painted face on Kuznetsky Bridge in Moscow. The poet Kamensky planned excursions with Mayakovsky and David Burliuk: 'In exactly three days at noon, all three poets – Mayakovsky, Kamensky, Burliuk – gaudily dressed, wearing top hats, their faces painted, will go to the Kuznetsky Bridge and, walking there, will take turns reciting their poems, aloud and with complete seriousness.'[40] The futurist Benedikt Livshits described Mayakovsky's 'green overcoat, which must have been bought the day before, and his glistening top hat [which] changed his appearance completely. In contrast to this foppish attire was his bare neck and light orange tunic.' After these initial experiments 'he found a black and yellow striped fabric of unknown origin, and decided to buy it'. His mother made it into the celebrated yellow waistcoat by which Mayakovsky became well known in his futurist years.

A photograph records David Burliuk in the top hat and striped waistcoat, probably borrowed from Mayakovsky. Only one half of the waistcoat was striped. The wooden spoon and top hat are in place. He also wears a pendant earring, and, perhaps, eye make-up. His face is decorated with a drawing of a bird in a tree. The agreed rules of engagement said 'Do not pay attention to the possible sneers of fools or to bourgeois derision', and 'Answer to all other questions that this is how futurists live. Do not interrupt us in our work: Listen.'[41] Another photograph shows Mayakovsky in a

glistening jacket and a large decorative cravat. Beside him, his face intensely serious, sits Burliuk, his lorgnette raised to his eyes like a connoisseur, and on his cheek and brow silhouettes of a dog, black cats and an arrow suggesting an aggressive chase across his face.

By subverting conventions, they gained rapidly in notoriety and fame. Kamensky recalled Mayakovsky painting the dog on Burliuk's face and 'with a crayon Mayakovsky drew an aeroplane on my forehead'. In Kamensky's case this identified his activities as a pilot. All three wore wooden spoons in their lapels and stepped out onto Kuznetsky Bridge in Moscow. To the growing crowd Burliuk roared 'you have before you poets of genius, innovators, futurists: Mayakovsky, Kamensky, Burliuk. We are discovering the America of new art. I congratulate you!'[42]

The face-painting of Larionov, Goncharova and Zdanevich tended towards lettering, music, punctuation and the crosshatched diagonal lines of rayist drawings. It was the Burliuk–Mayakovsky–Kamensky model of futurist genius that inspired Malevich to paint *Englishman in Moscow* of 1913–14 [p.23]. It has been suggested that the painting depicts Kruchenykh, though Burliuk seems a likelier possibility, while Malevich's *Aviator* probably depicts Kamensky.[43]

Burliuk stares out like the figure of a saint. The mask-like anonymity suggests that a single, specific model may not be intended or important. But he is clearly a futurist in his top hat, the formal outfit, and the spoon that was originally attached to the canvas. The images of church, candle and perhaps even the ladder, all have Christian significance. The images of bayonets and the sabre are military and refer to the Balkan Wars close to Russia's borders. These overlap the figure and lie before him. Behind him are a saw, a sign for the Horse Racing Society and scissors. These may be street signs. The expressionless face fits the futurists' plan to recite poems in 'complete seriousness', paying no attention to sneers and derision. According to Kamensky 'We walked with serious, stern expressions, without even smiling.'[44] Kamensky mentioned too an officer strolling past. Perhaps the futurist 'genius' is walking past a betting shop and a sawmill, on his way to the church and barracks that still lie before him. These may be simultaneous impressions of sights and sounds, like those Larionov drew, that excited Boccioni, Balla, Carrà, and most of all the Italian futurist composer–painter Luigi Russolo, whose *Art of Noises* so dismayed the journalist of the Moscow Gazette on 7 October 1913, that he said that the *Slap in the Face of Public Taste* seemed 'only a pitiful childish model in comparison with the

Kazimir Malevich
Englishman in Moscow
1914
oil on canvas
88 x 57 cm
Stedelijk Museum
Amsterdam

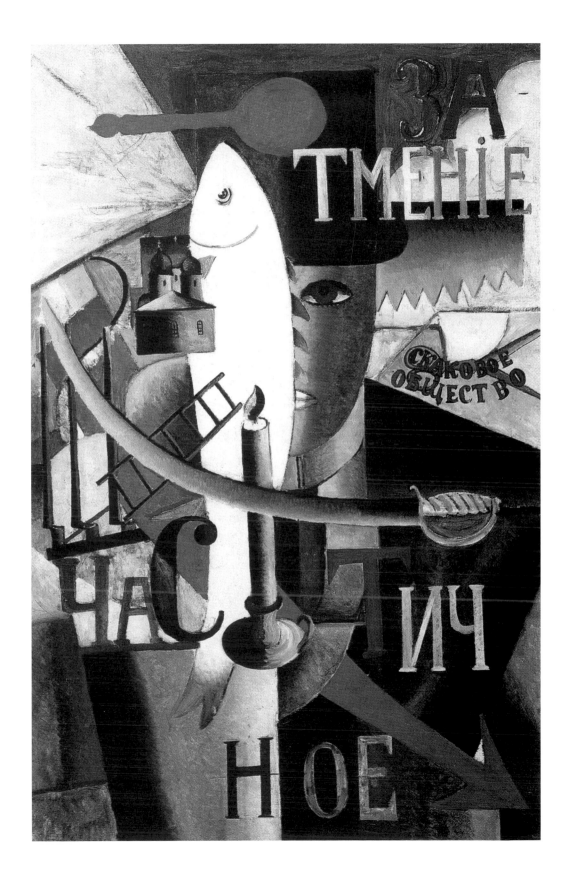

hysterical plans of the West European lunatics'.[45]

The increased production of futurist books in Russia in 1913 led to a fusion of verbal and visual material. Malevich also attempted this kind of fusion in his painting *Englishman in Moscow* [p.23], which is inscribed in large colourful letters: ЗАТМЕНІЕ ЧАСТИЧНОЕ (*zatmenie chastichnoe*, partial eclipse). He split these words into fragments on this canvas. ЧАС (*chas*), a fragment from the word for partial, is also a word meaning hour, time, clock, or watch. Here the sabre and red arrow sweep across the canvas like the hands of a clock. Larionov, in an illustration for *Le Futur*, used arrowed clock fingers and the painter Lyubov Popova used the letters ЧАС exactly as Malevich had, but referring solely to a clock. Malevich embeds the theme of time into his inscription and his images to make a verbal and visual construction.

There is an atmosphere of oppressive premonition, of militarism stirring, of sharp devices – bayonets, sabre, saw, scissors, forms themselves in partial eclipse, with the military sabre uppermost. The military power partially eclipsed may be the autocracy of the Romanov dynasty, publicly celebrating its anniversary in 1913.[46]

Beyond the Sun

Moscow futurists argued in meeting after meeting. Posters announced 'Futurists – An Evening of Speech-Creators' ('*Futuristy. Vecher Rechetvortsev*') at the Hall of the Society of Art Lovers on 13 October 1913, billed as the first event of its kind. David and Nikolai Burliuk, Kruchenykh, Livshits, Mayakovsky, Khlebnikov and Malevich were all there. The newspaper *Russkie vedmosti*, described the hall overflowing with people and police, and with 'the heroes of the evening … appearing here and there, thus stimulating the excitement of the already excited public. The most heroic of them [Mayakovsky] was dressed in a curious tunic of yellow and black stripes.'[47] Mayakovsky declared 'We are destroying your old world', and when he discussed the layers of fat in his audience, the glittering cavalry officers in the front row rattled their sabres against the floor, making 'a sound like a worn out engine'. A little later Kruchenykh splashed the front row with hot tea.

Events multiplied. On Sunday 3 November 1913, David Burliuk presented the lecture 'On the Futurists' in the Concert Hall of the Tenisheva School in St. Petersburg. He described Khlebnikov as a poet to demolish literature. He discussed Livshits, Mayakovsky, Kruchenykh and his brother Nikolai Burliuk, and compared futurists in Italy and Russia, concluding with a tribute to Khlebnikov.

The last Union of Youth exhibition opened in St. Petersburg one week later, running from 10 November 1913 to 10 January 1914. While Larionov and Goncharova remained independent, the Burliuk brothers, Mikhail Matiushin, Tatlin, Shkol'nik, Alexandra Exter all exhibited. Malevich made a dramatic and powerful contribution with his *Knifegrinder* [p.17 below], *Woman with Buckets (zaum-realism)*, his *Reaper* [p.25 left] and *Samovar (cubo-futurist realism)*.

At this point Olga Rozanova dramatically seized upon the urban and mechanical tumult that Marinetti promoted. Italian futurists hardly made a more energetic rendering of the industrialized city than that presented by Rozanova in 1913. Her *Factory and Bridge* splinters images in hectic, clashing antagonism, vigorously agitating the canvas with industrial energy. Windows, chimneys, machinery and roofs launch themselves one against another. Comparable explosive energy had informed her illustrations for issue number three of the *Union of Youth* periodical in 1913. Her crystalline geometry, agitated and transparent in its effects, suggested factories, smoke and physical labour, though she spelled out none of the detail. Ships in port are seen against a line of bridges, and warehouses and factory chimneys strain for the sky above the dense activity of the street. These were her themes as winter gripped St. Petersburg in 1913.

By contrast Malevich began to unite cubist and futurist techniques to depict static objects. When Italian futurists painted static objects, they used them as a focus of simultaneous impressions or as a visual armature for their 'lines of force' in which the dynamics resulted from perception of the object as much as its structure. But Ardengo Soffici's *Deconstruction of the Planes of a Lamp* [p.50], painted in 1912–13, is closely comparable to Malevich's technique, both in forms and techniques. Russians called this blending of techniques 'cubo-futurism'.

In association with Goncharova, Malevich had adopted peasant themes. The futurist peasant was a strong and substantial motif, built up from firmly modelled planes and starkly lit forms. In *Head of a Peasant Woman*, her face is almost lost in the kerchief knotted under her chin. She appears immovable, an intense focus of forms around a central axis, narrative cast aside. Boccioni's *Study for 'Empty and Full Abstracts of a Head'* [p.43] makes a

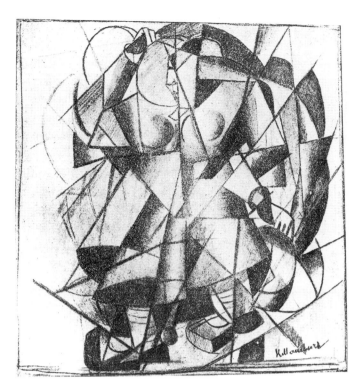

Kazimir Malevich
Reaper, published in *The Three*
1913
letterpress
13.8 x 13 cm
Private collection

Kazimir Malevich
The Simultaneous Death of a Man in an Aeroplane and on the Railway
published in A. Kruchenykh's *Explodity*
1913
lithograph
9 x 14 cm
Private collection

useful comparison, but Malevich's owes as much to the icon as to Italian futurism: his peasant woman is immovable, anonymous and without individuality.

Here Malevich begins a curious word-game of his own. As his comparable lithograph *Prayer* indicates, the peasant is devout. In Russian peasant woman is *krest'yanka*, but *krest'* means cross, and *krestit'* to baptize. Here is a conjunction of images that Malevich can explore both visually and verbally.

But machinery does appear in his lithographic illustrations to Kruchenykh's book *Explodity* in 1913 [p.71]. The cover by Nikolai Kulbin depicts a rowdy futurist meeting in which an orator harangues his rebellious audience. Malevich included his lithograph *Prayer* into this book, as well as the extraordinary lithograph *Simultaneous Death of a Man in an Aeroplane and on the Railway* [p.25 right]. Goncharova also tackled this otherwise

unique subject in a large oil painting *Aeroplane over Train*, (1913, Kazan Art Museum). Propeller-driven plane, telegraph poles and cables, railway lines and a train are spliced together. Malevich's *Pilot* appeared in the book *The Three* with numerals, letters, musical notes and punctuation marks, a synthesis of references derived from mathematics, algebra, poetry, music and drawing.

The books *Explodity* and *The Three* are forerunners of the project for a Russian futurist opera, a plan first hatched by Matiushin, Kruchenykh and Malevich in July 1913. Their grandly titled 'First All-Russian Convention of Futurists', apparently just the three of them, met at Matiushin's dacha at Uusikirkko on the Finnish Karelian isthmus. Their forthcoming 'theatre for future-people' was based on their new word *Budetlyanin*, future-dweller, a term neither containing nor requiring any reference to futurists in Italy.

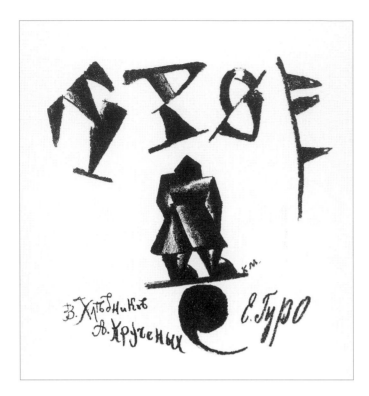

Kazimir Malevich
Cover for *The Three*
1913
lithograph
19.8 x 18.3 cm

A book devised at Uusikirkko has the futurist peasant on the cover [p.26]. The title TPOE (*Troe, The Three*) is constructed with wedge-shapes like cuneiform writing. Kruchenykh had asserted that Russian futurism had direct links with the far-off past as well as the future, aiming to be 'extra-temporal' just as *zaum* language was 'beyond sense',[48] and he had also called for meaning to be assigned to graphic as well as phonetic characteristics of letters. Malevich here links futurism to Babylon.

There is also a visual metaphor here. The letter O of the title is split with a line. Malevich did this in contemporary portraits of the painter Kliun, where he relates око (*oko*), an old word for eye, and окно (*okno*), meaning window. In the Kliun portraits one eye is split as here, but the other contains a view of a wooden hut. The peasant rural worker theme also persists in the portraits of Kliun, just as here in the title TPOE, where the letter E forms the teeth of a saw, rake or jaw.

The opera *Victory over the Sun* alternated with *Mayakovsky,*

a Tragedy, written and performed by the poet. A dynamic three-colour poster designed by Olga Rozanova announced in rough, scattered and hardly legible lettering 'First Ever Staging of Futurist Theatre 2–5 December 1913' [p.27]. Rozanova's imagery is not easy to recognize, but beneath the top hat is the leering face of the Russian futurist. His body here forms a great curve across the poster encircling the scattered letters of ФУТУР ТЕАТР, Future Theatre.

Victory over the Sun opened on 3 December 1913 at the Luna Park Theatre in St. Petersburg, with a prologue by Khlebnikov, libretto by Kruchenykh, music by Matiushin, and design by Malevich [see pp.74–75]. A second and final performance of the production took place two nights later. Timed to coincide with the exhibition of the Union of Youth, its sponsors, the opera was the Russian futurists' most innovative and ambitious project to date. It marked the culmination of a brilliant and prolific year of paintings, books, exhibitions, debates and performances in St. Petersburg and Moscow.

A second poster incorporated a lithograph by David Burliuk that was also printed on the back cover of the libretto. This poster listed the characters in *Vladimir Mayakovsky*, including 'V.V. Mayakovsky – a poet, his Girlfriend (14–21 feet tall, unspeaking), an Old Man (several thousand years old) with dry black cats, a Man without eyes or feet, a Man without ears, a Man with no head, a Man with two kisses, an Ordinary Young Man, a Newspaperman, Boy, Girls, and so on.' These characters, painted on frames by Pavel Filonov were moved and held by actors. The writer Viktor Shklovsky remembered Mayakovsky's speech about black cats: 'Dry black cats emit electricity when one strokes them … The purpose of his cats argument was something like this: electricity can be got even from a cat. The Egyptians had done this. It is more convenient, however, to provide electricity by industrial methods and leave cats alone. The old art, we then thought, had achieved its effect in the way that the Egyptians produced electricity, whereas we wanted to obtain pure electricity, pure art.'[49] David Burliuk included an image of the scene in the text published in Moscow in 1914.

Protagonists of both productions posed in the photographic studio of Carl Bulla, before an inverted backdrop of a window, bookcase, curtain and piano. The 'future-dwellers' of the new theatre pose in solemnity among inverted tables and chairs. In one photograph Kruchenykh lies across their knees, his arm outstretched in declamation, his mouth open and his eyes

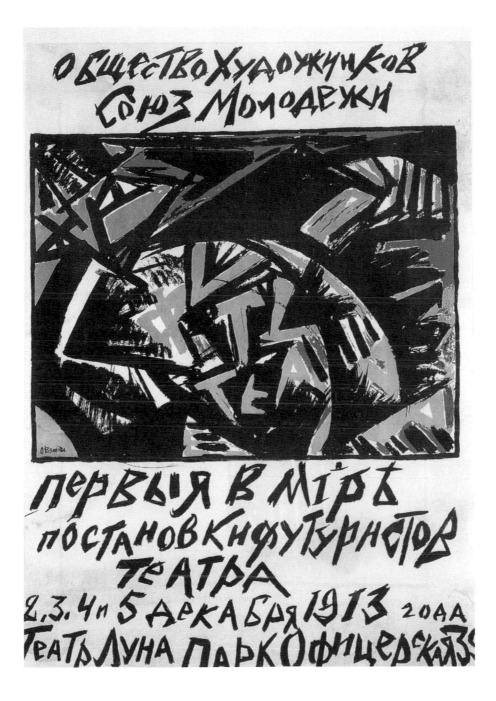

Olga Rozanova
Poster for *First Productions in the World of Futurist Theatre*
1913
colour lithograph
91 x 65.5 cm.
Private collection

wide, as Malevich and Matiushin pretend that nothing strange is happening. Here gravity might lose its grip, and perspectives lose their power to fix an illusion of unified time and space in the multiple dimensions of *Victory over the Sun*. 'How extraordinary life is,' declaims one character in the opera, 'without a past, with danger, but without regrets or memories…'[50]

The opera shows the futurists capture the Sun, box it, kill it and hold a funeral. The partial eclipse is now total. Without the sun, day and night, the cycle of the seasons and all the calendar of our days and lives, is lost. The world that follows is dark and frightening. But without the sun structuring time and space, the prospect of timelessness emerges and the vast relativity of space. Malevich would later call this breaking through the horizon. In the opera this permits the Aviator to travel through the centuries,

appearing suddenly and with a crash from another dimension.

Matiushin's experimental music and Kruchenykh's *zaum* speech made no concessions to the audience, but as a spectacle of sound, colour, words and music it was successful. Both performances were sold out and the audience applauded, hissed and threw things at the stage.[51]

Malevich used coloured spotlights that radically altered the appearance of his costumes to make a colourful and kinetic rayist composition on stage.

The conical rays in his lithograph *Pilot,* published in *The Three* may indicate his plan for the aviator's abrupt arrival in the last scene of *Victory over the Sun*. This hectic structure also featured in *Simultaneous Death of a Man in an Aeroplane and on the Railway*. The Aviator was not killed in *Victory over the Sun*, but he certainly crashed, and the plane's wheels, visible here, also appear in the set design that appeared on the cover of the libretto published in 1914. Here is the Sun (partly eclipsed) and the Cyrillic Кр (*Kr*) of Kruchenykh's name.

Black darkness descends as the bright eye of the Sun is eclipsed. The potential for dramatic effects of lighting was enormous – in colour, intensity, shifts of direction, in the rhythm of the changes that could be slow, sudden, smooth, or abrupt with a hectic flashing of rays, brilliance or total darkness. The effect of powerful coordinated beams of light in unfamiliar colour combinations from several directions was a new spectacle, and a new medium for Malevich that he could use to develop the recent rayist innovations of Larionov and Goncharova.

Earlier in 1913 Larionov and Ilya Zdanevich had released the manifesto *Why We Paint Ourselves* in which they imagined this kind of futurist fragmentation of experience: 'We paint ourselves for a passing moment and the change in experience causes the change in colour; as image devours image, as shop windows flicker and mingle with each other, seen from a moving car – so it is with our faces.'[52]

The opera opens in the ancient world seen from new perspectives. Old-timers (Nero and Caligula) grumble at the frightening changes brought from the future by Strongmen and a Time-traveller. In Scene Two there is a chorus, an Enemy (or Turks, in some drawings), and Sportsmen in colourful costumes. Scene Three ends with the burial of the Sun. In the second half, the new space-time develops, and we see a house built inside out with the universe within its windows. Finally the New Man appears crashing the plane that carried him through time and space.

At that time futurists in St. Petersburg regularly gathered and performed at the Stray Dog Cabaret. In a letter of 9 December, Olga Rozanova described how 'I hang out at the Stray Dog. One night there was a kind of *apaché* evening, an unusual Saturday, and I sat there the whole night through from 12:30 to 7:30 am. I got there on the last tram and left on the first.'[53] The next night, at the 'First Evening of Everythingism', Larionov, Goncharova, Zdanevich, Le-Dantyu and others announced 'freedom from time and space'. They also prematurely declared the end of futurism.[54]

On 22 December 1913 the Stray Dog Cabaret held a discussion of the work of Sonia and Robert Delaunay. A. Smirnov lectured on the poet Blaise Cendrars, and presented Sonia Delaunay's hand-decorated scroll of Cendrars' *Prose du transsibérien de la petite Jehanne de France*. With the arrival of the long, colourful scroll a contemporary Orphist work had arrived in St Petersburg.[55] Chagall too was in contact with Cendrars' and the Delaunays' Parisian circle, as were Alexandra Exter and Georgiy Yakulov, both of whom were developing new theories of light and colour in painting and on stage. But independence from the West remained a sensitive issue. On New Year's Day 1914, for example, Yakulov, Livshits and Matyushin's pupil Artur Vintsent Lure (Arthur Vincent Lourié) issued *Poster No.1: We and the West*, to spell out once again their conviction that the future of painting, literature and music lay in the East.

Radical books flourished in 1914. Kruchenykh and Khlebnikov's *Game in Hell* [p.67] was illustrated by Rozanova and Malevich, while Rozanova and Kulbin illustrated their book *Te li le*, and Vasili Kamensky's *Tango with Cows*, which appeared in multiple fonts printed on coloured wallpaper. At the same time the Russian press took increasing notice of the Italian futurists. In Moscow Vadim Shershenevich translated and published Marinetti's *Manifesto of Italian Futurism* with Pratella on futurist music, Marinetti's *Technical Manifesto of Futurist Literature*, Russolo's *Art of Noises*, Carrà's *Painting of Sounds, Noises and Smells*, as well as Marinetti's *Variety Theatre* manifesto. Shershenevich also wrote about Marinetti in his book *Futurism without a Mask*. Marinetti, writing without punctuation in his memoirs, recalled the approach of the critic Genrikh Tasteven one evening in Paris: 'Polymaterial environment with surprises Tasteven a small carefully dressed gentleman looking like an important official of some ministry comes over to greet me his blond goatee twitching and his little red Russian eyes sparkling'.[56] Tasteven invited him to Russia. Marinetti agreed.

FUTURISM: MARINETTI IN RUSSIA

Some thought that the enemy was now in the camp. They expected to be patronized, even colonized, into his international futurist movement. There was every prospect of conflict. A newspaper journalist interviewing Tasteven, Larionov and Goncharova announced that 'The founder of futurism is coming to Moscow on Sunday and ears are already twitching.' Tasteven planned a speech of welcome at the station and took 'every precaution against hooligan pranks of the well-known kind. There will be several stewards in the auditorium for the lecture.' Larionov and Goncharova were dismissive: 'Marinetti is already past his first freshness as a futurist. Many of his first adherents have already come out against him. Personally, I do not advocate throwing rotten eggs at Marinetti, and do not propose either to present him with a bouquet of flowers. Enough eggs have been thrown at him already! But it would not be surprising if others did it. The futurists discussed this, and I cannot be sure that it will not happen at Marinetti's lecture.'[57] For Goncharova, Marinetti was just an academic resting on his laurels.

The same newspaper on 28 January 1914 devoted several articles to 'Marinetti in Moscow': 'On Sunday the leader of the futurists, Marinetti, arrived from Milan. He was met with little ceremony. Only a few people came to the platform of the Alexandrovsky Station. Among them were Tasteven, A. Tolstoy, P. Kozhevnikov, Shershenevich, and Bolshakov. Tasteven made a speech of welcome.' Marinetti replied with a call for solidarity among futurists: 'we shall fight together,' he announced, 'and I am sure that we shall very soon achieve good results.'[58]

Another journalist described him: 'not very tall, stocky, with sharp movements, confident, with bright eyes… Such is the leader of futurism, its founder and tireless promoter, the Italian Marinetti.' Marinetti seized the initiative: 'I am very glad that I had the chance to come to Russia, a country so young. She has everything in the future, in creation. It is certain that futurism – this poetry of the future, hastening to create new forms, will have a great success in your country.' He explained that 'every thing that surrounds us finds itself in constant movement, in continuous creation and decay. Only art and literature remain free from the raging tempo of life. Like captives they are tied with chains to the beauty of the past and all of them still extol the flight of the swallow and the running of the horse, ignoring the beautiful aeroplane and the powerful engine. This imprisonment of art we want to destroy.

We shall sing of the progress of industry, skyscrapers and cinema, radio and X-rays, aeroplanes and electricity… Until now all of this has been considered somehow improper for poetry. And so *we poeticize the mechanical culture of modern life*.' His final words revealed his international aims: 'I firmly believe that all futurist ideas are worked out in the existence of life itself, and so we are not far from the time when futurism will conquer the whole world.'[59]

Futurists looking east could scarcely welcome Marinetti, but they could turn and fight. Marinetti's *Founding Manifesto* had declared that 'there is no more beauty except in strife'. Mayakovsky had already recognized the Italian futurists as 'men of fist and fight' in a lecture on 11 February 1913.[60] Larionov wanted an aggressive response, and Khlebnikov had to be restrained.

Yet their futurist creativity was at its height in 1914, in painting, music, poetry, theatre, publishing, debates and events. An assertion of independence was wholly justifiable. Larionov and Goncharova had just released *Drama in the Futurists' Cabaret No. 13* [see page 8], a film in which futurists with painted faces gather for a murderous dance in which one must kill another.[61] Larionov's character dances with his partner (Goncharova) and kills her. In the surviving film still Larionov carries out Goncharova to leave her in the snow. Futurist film had followed swiftly on the innovations of *Victory over the Sun*.

In a letter to the newspaper *Nov'*, Burliuk, Kamensky and Mayakovsky made it clear that 'imitating the Italians (or vice versa) is not something that could even be discussed'.[62] For better or worse, these three vital figures had just begun a long and ambitious tour, performing at futurist evenings in the south of Russia.

Then Marinetti arrived. Larionov said that he 'preaches old rubbish. He is banal and vulgar, fit only for a mediocre audience and narrow-minded followers',[63] but Malevich was supportive. Marinetti's arrival threatened to split the movement. 'After a deep sleep', wrote Marinetti, 'I awake in the austere barren frozen Moscow railroad station feeling like a piece of lost luggage.' It was 26 January 1914. He revived rapidly, and when he spoke at the Moscow Polytechnic Museum the following day, the press reported that: 'a lot of people turned up, and there was a cheerful atmosphere… everything went off peacefully and quietly.' He described Marinetti as 'dynamic, a nervous figure, ceaselessly moving, rising to anger or generosity, a stormy cascade of words…' He concluded with a ferocious performance of poems about the Balkan wars, and 'in the end Marinetti grew hoarse. He suddenly

stopped, made meaningless hand gestures and explained – "I have lost my voice". For several minutes he again appeared on the platform and tried to finish his lecture. Noise broke out, long applause. The lecturer evidently knew how to hold the attention and the emotions of his audience.' But there was no violence and, no rotten eggs.[64]

He spoke again at the Small Hall of the Moscow Conservatory on 28 January: 'my lectures gather a large crowd that receives me ecstatically'.[65] Never a modest man, Marinetti noted how 'my personal successes follow one on the other and the more or less coy plots to checkmate futurism multiply.'[66]

The next day he noted 'Triumph – in all the bookstores and smart shops there's a caricature of me in the window showing me half bombarded with rotten fruit [Milan] and half colonized by feminine hearts [Moscow].'[67] On 31 January the papers reported that 'the public applauded the orator and surrounded him in a great circle as he made his exit'. There was no attack from the 'Moscow futurists headed by Mr Larionov, who were present'.[68]

Marinetti was in St. Petersburg from 29 to 31 January, where he attended the Stray Dog Cabaret. He found it 'luxurious enough but I feel like a wild dog forced to bark for his supper no matter how tired and longing for a sleep and Italian solitude'. He described the interior: 'the downstairs of the Sabacha [Marinetti's version of *Sobaka*, Dog] is made up of about seven rooms painted and draped with a variety of materials velvet and purple brocades and many portraits of me done by Kulbin and Larionov'. According to Marinetti, 'the leader of the Donkey's Tail group', Mikhail Larionov, 'bursts in to drive away the blood-thirsty excited beauties with Russian imprecations and offers me a gold nugget from the Caucasus as a gift…' Marinetti was convinced that 'the group are now half-converted to Italian Futurism'.[69]

When Nikolai Kulbin held a reception for Marinetti, Khlebnikov wanted to strike him. Matiushin recalled that Marinetti 'gave a good description of the noise of a propeller, explosions and drumbeats, which were evidently meant to demonstrate the coming war in Europe'.[70] A photograph shows a mass of formally dressed people gathered around Marinetti and Kulbin, including Lourié, Livshits, Nikolai Burliuk, and Olga Rozanova. To Kulbin's fury, Khlebnikov and Livshits distributed a protest note saying that 'Some natives and the Italian colony on the Neva are, for personal reasons, bowing today at Marinetti's feet, thus retracting the first step of Russian art on the road to freedom and honour, and bending the noble neck of Asia under

Europe's yoke.'[71] At the very moment when futurists were in the south, Marinetti had arrived to magnetize audiences and draw them to him. Kulbin was making dynamic drawings of Marinetti as he performed. It was a critical moment. Marinetti argued that both the Italian and Russian futurists were fighting the past and he gave Livshits a drawing showing the sharp point of futurism splitting open all opposition, inscribed 'to my Russian Futurist friends against all passéisme', and signed 'FuTurist Marinetti'.

Once Marinetti was on his way back to Moscow, Livshits and Lourié organized 'Our Reply to Marinetti', featuring Livshits on 'Italian and Russian Futurism and their Relationship', and Lourié on 'The Music of Italian Futurism'. Kulbin, Kruchenykh, Khlebnikov and Matiushin were all there.

In Moscow Marinetti visited Sergei Shchukin, the merchant who, on his frequent travels to Paris, had amassed a vast collection from Impressionism to the most recent works by Matisse and Picasso. Matisse visited Moscow for Shchukin's commissions to paint *La Dance* and *La Musique*. Shchukin became an influential force in the life of Moscow artists who saw some of the latest Parisian art in his palatial collection. Even Russian futurists went there: Kamensky made a poem 'Shchukin's Palace' for *Tango with Cows* in 1914. Although Marinetti called him Shimkin, the collection impressed him and he hoped Shchukin would buy Italian futurist works: 'While I'm enjoying Matisse's genius and happy learn that the gallery will soon acquire futurist works by Boccioni Severini Russolo Balla Carrá'. This would have been a devastating triumph for Marinetti as Shchukin owned no Russian futurist works.

Larionov and Goncharova took him to see Mayakovsky perform. Marinetti saw him as 'a clown on stage with the red cloak gold cheekbones and blue forehead… an imbecile in red arguing with four idiots in black.'[72]

A masked ball followed at which, said Marinetti, he had various amorous escapades. Malevich designed a costume, inscribed *Maskarad*, incorporating the futurists' spoon and top hat. 'Without the slightest exaggeration,' wrote Marinetti, 'I declare that that masquerade ball with its amazing costumes and fabulous prizes given in Moscow in my honour constitutes my most successful aeropoem in words-in-freedom.'[73] He took the credit.

Marinetti performed 'The Battle of Adrianople', 'my great polyphony of an army marching into the burning sands and the Tripoli-smelling souk. But the popping of enemy bullets don't hurt at all because they're most probably the champagne corks

flying!' On his third night of partying, Marinetti confidently declared: 'To the Russian soul I send a plea for the recovery of Russian Futurism,'[74] calling it 'not futurism but savage-ism and its followers not futurists but savage-ists, primitivists'.[75]

David Burliuk and Mayakovsky were still on tour performing with painted faces, in city after city, to astonished audiences. At Kazan Mayakovsky wore a fine waistcoat and a large necktie for his presentation on 'The Achievements of Futurism'. Burliuk had a horse painted on his cheek and wore a satin waistcoat for his talk on 'Cubism and Futurism', while Kamensky, wearing a lounge suit and a florid handkerchief, had a horse painted on his forehead for his lecture on 'Aeroplanes and Futurist Poetry'. They performed in Simferopol, Sevastopol, Kerch, Odessa, Kishinev, Nikolaev, Kiev, Kazan, Samara, Rostov, Saratov, Tiflis (Tblisi) and reached Baku by March 1914. In February 1914, Burliuk, Kamensky and Mayakovsky wrote to the press that 'while on tour in the provinces, we witnessed from afar the tragic-comic "conquest" of Moscow by Mr Marinetti…We had nothing to do with Italian Futurism.'[76]

But Marinetti had undoubtedly won support: Malevich and Kulbin were sympathetic. Olga Rozanova was impressed and Ilya Zdanevich had declared allegiance at Marinetti's farewell event, declaring that 'a group of Moscow futurists felt solidarity with Marinetti and regarded him as their excellent leader'.[77] Marinetti invited Russian futurists to exhibit at the Sprovieri Gallery in Rome, and on 21 February 1914 Kulbin wrote to Malevich, Rozanova and others inviting them to contribute to Marinetti's International Free Futurist Exhibition, for which he had already acquired drawings by the sculptor Alexander Archipenko.[78]

The *Esposizione Libera Futurista Internazionale* (3 April – 25 May 1914) included paintings and sculptures from Italy, Russia, England, Belgium and North America, organized by the Movimento Futurista of Milan, director F.T. Marinetti.

Not surprisingly, the Italian section was largest and noisiest, with works by Marinetti, Balla, Cangiullo, Depero, Prampolini, Sironi and even Morandi, among others. The Russian section comprised Archipenko, Exter and Kulbin (listed Nicola I. Kulbin). He exhibited *Head + Sun = Interference* and *Portrait of F.T. Marinetti (Interference)*. Rozanova (listed as Olga V. Rosanoff), exhibited six works including *The Port*, *Factory and Bridge*, as well as *Dissonance* and *Man in the Street*, and illustrated books by Kruchenykh and Khlebnikov, among them *A Duck's Nest of Bad Words* and *Te li le* in which Kruchenykh had published his seminal *zaum* poem: *Dyr bul shchyl / ubeshshchur / skum / vy so / l dz*, the

first of 'three poems written in my own language different from others in that the words have no definite meaning'.[79] He had asked Marinetti in Russia whether the Italians had anything like it, and Marinetti said no. The gallery's director, Sprovieri, implied that Larionov and Goncharova exhibited, but they did not appear in the catalogue, and there was no sign of Malevich.[80]

There were many tributes to Marinetti, including his own *Self Portrait (Dynamic Collection of Objects)*, and a *Portrait of Marinetti* by Italo Griselli (Grizelli) who moved to St. Petersburg within the year. There was also *Facial Dynamic of Marinetti* and a *Facial Synthesis of Marinetti* by the 'English futurist' poet and painter Mina Loy who was in a close friendship with Marinetti.

Alexandra Exter knew the critic and painter Ardengo Soffici in Florence and she had been friendly with Marinetti in Moscow. She and Rozanova were guests of Rugena Zatkova, wife of the Russian diplomat Vasili Kvoshinsky in Rome.

Russian futurism was inadequately represented in the Rome exhibition, but internationalism attracted some Russian artists. Lyubov Popova studied cubism in Paris under Jean Metzinger, but she also responded to Italian futurist art there. She travelled to Italy in 1914, and a *Still Life*, now in the Ludwig Collection in Cologne, is inscribed 'Rome'. Her *Portrait* [p.53] of 1914–15 is inscribed 'Cub' and 'Futurismo'. She made an *Italian Still Life* of 1914 and her *Philosopher* of 1914–15 has fragments of the word *LACERBA*, the Italian futurist periodical. Exter's friend Ardengo Soffici was based in Paris, and it was the cabarets of Paris that gave the city scenes of Severini their scintillation.

On 21 May 1914 the Paris Opera (Opéra Garnier) launched Diaghilev's production of *Le Coq d'or*, the Golden Cockerel, designed by the futurist Goncharova [see pp.64–65]. At a stroke this production returned the Russian 'savage-ists', as Marinetti had called them, to the heart of Paris. It was the same synthesis of folklore and Russian futurist dynamics that had motivated the Donkey's Tail group. Goncharova's insistence on the Russian peasant, defying current art in Paris, found fruition in Paris itself. It is ironic that this thrilling assertion of Russian culture took Goncharova away from Russia.

This set the futurism of Larionov and Goncharova in a whole new context, with a joint exhibition at the Galerie Paul Guillaume in Paris, and support from Apollinaire who declared Goncharova 'the head of the Futurist school'. Diaghilev had again played a catalytic role.

MYSTICAL IMAGES OF WAR

War in August 1914 changed everything. David Burliuk wrote of Larionov, Livshits and Kamensky, 'caught up in this hurricane'.[81] Larionov was soon seriously wounded. Creative people were dispersed and contacts lost. Travel to Berlin or to Paris ceased. Cultural isolation was replaced by revolution, civil war and more isolation.

In 1909 Marinetti's *Founding Manifesto of Futurism* praised war as 'the world's only hygiene'. Militarism was part of their outlook. Carrà's *Patriotic Celebration*, Boccioni's *Charge of the Lancers* and Severini's *Armoured Train* are all examples. Carrà's *Atmospheric Swirls – A Bursting Shell* of 1914 [p.33] celebrates the noise of battle.

Russian futurists did not share this militaristic enthusiasm, though warfare became an important theme in their publications of 1914–15. In Goncharova's lithographs for *Mystical Images of War* [pp.80–82] published in Moscow in 1914, angels fought aeroplanes, caught in an apocalyptic vision of fighting, flight, fall and destruction.

In November David Burliuk, Malevich, the painter Aristarkh Lentulov and Vladimir Mayakovsky all exhibited in 'War and the Press'. The project 'Today's *Lubok*' employed them in a scheme to make agitational posters of the war in colourful *lubok* styles for mass distribution. Malevich moved with ease into this field, and Mayakovsky began the intense, public, and politicized art that changed his career.

Even in 1915 futurist poems and essays were published. *The Archer* (*Strelets*) published Mayakovsky's famous poem 'A Cloud in Trousers', written about and to Lilya Brik, the wife of his friend Osip Brik. Kamensky recalled its launch at the Stray Dog Cabaret where the writer Maxim Gorky showed interest in futurism, only later to deny its existence, as it lacked coherence without a leader like Marinetti.[82]

Futurist exhibitions continued isolated from West European input. A Committee of the First Futurist Exhibition organized 'Tramway V' in March–April 1915 in Petrograd, featuring Exter, Malevich, Kliun, Popova, Ivan Puni, Rozanova, Tatlin and others.

In a photograph published as a futurist Easter greeting in the *Blue Magazine* (*Sinyy Zhurnal*), No. 12, in March 1915, Kulbin, Rozanova, Lourié and Kamensky are seated in a studio. The painter Ivan Puni and Mayakovsky stand behind holding Yakulov's portrait. Lourié's head, cut from the photograph of Marinetti's reception, has been pasted onto someone else's body, perhaps Puni's, whose own head floats free above the group.

In Moscow the exhibition 'The Year 1915' allowed Chagall to make his mark with twenty-five paintings. There were nine works by Larionov and four by Goncharova.

The 'Exhibition of Leftist Tendencies' opened in April at the Dobychna Art Bureau on the Field of Mars in Petrograd. Exhibitors included David Burliuk, Kamensky, Kandinsky, Kulbin (his *Portrait of Marinetti*), Puni, Rozanova and Yakulov. Rozanova illustrated Kruchenykh's *War*, published in 1916, with energetic images of firing soldiers, falling aeroplanes, and exploding canons [p.32]. Goncharova, Burliuk, Malevich, Mayakovsky, Rozanova and Chagall all depicted the conflict. Matiushin and Malevich planned an interstellar and militarized revision of *Victory over the Sun*. Khlebnikov made mathematical and poetic analyses of war. Malevich wrote to Matiushin asking for a black square to be used in the act where the victory occurs and utter darkness descends: 'the curtain depicts a black square, the embryo of all possibilities; in its development it acquires a terrible strength'.[83]

These designs have flat geometric planes among the images, reminiscent of Kulbin and of vorticism. They relate ultimately to Malevich's backdrop, the 'black square' mentioned in his letter to Matiushin. But his notorious painting, *Black Square*, made a few

Olga Rozanova
Illustration to A. Kruchenykh's *War*
1916
linocut
41.2 x 30.4 cm
Private collection

Carlo Carrà
Atmospheric Swirls – A Bursting Shell
1914
ink and collage on paper
26.5 x 37 cm
Estorick Collection, London

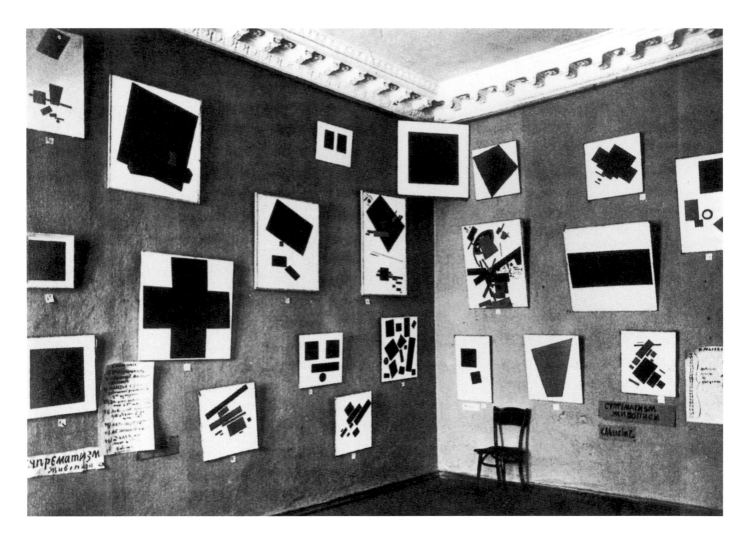

Paintings by Malevich at the exhibition
'0,10, The Last Futurist Exhibition' Petrograd
17 December 1915 – 17 January 1916

months later, dominated his display at '0,10, The Last Futurist Exhibition', hung high across a corner space with a multitude of geometric works streaming down from its icon-like position of power and authority [p.34]. The *Black Square* for Malevich had eclipsed the sun. The negative painting, the reduction to nothing, coincides with Malevich's intention in May 1915 of devising a new journal called *Zero* (*Nul'*).[84] What followed was beyond perspectives of specific time and space. Here there was no shade, weight, or scale, but a dynamic space with no fixed points. This study Malevich named *suprematism*, 'the most appropriate word for it signifies supremacy'.[85]

In the midst of war, old values were falling away, and a threshold had emerged over which Malevich and fellow Russian futurists stepped into a new culture.

This so-called 'non-objective' art, or 'art without subject' to translate the term *bespredmetnyy* precisely, was a visual equivalent to the poets' studies of *The Word as Such*, and *The Letter as Such* that soon followed. Malevich had illustrated the cover of *The Word as Such* in which its self-sufficiency was made clear: 'we believe that language should be above all, language; if it recalls anything, this should be a saw or a savage's poison arrow', both motifs in Malevich's painting *Englishman in Moscow* [p.23].[86] The periodical *Apollon* (*Apollo*) noted that suprematism seemed to supersede cubism and futurism as a movement, but lacked any practical application.[87]

The new time and space depicted by Malevich approached the concepts of time and space devised by Khlebnikov, as everything

is relative to everything else; speed and rhythm relate only to slower movements, largeness only to smaller forms and distance only to nearness. These geometric forms, like the characters in *Victory over the Sun*, have escaped gravity for an environment with the features of space flight, beyond the sun in deep, high and bottomless space.

Malevich acknowledged his debt to futurism. Many followers seized on the implications of his new work. In 1916 Kruchenykh and Rozanova published the spectacular collage book *Universal War* [pp.76–77], in which energy, space and colour exemplify Khlebnikov's theories of time, space and the conflict of great cultures.

Malevich's chief competitor at '0,10, The Last Futurist Exhibition', Vladimir Tatlin, continued to consider himself a futurist. He too was a devoted follower of Khlebnikov, his ideas and his verse. Already in 1916 he was discussing flight as the first evolutionary step into new and wider concepts of time and space. A 'Futurist Lecture: Cast Iron Wings' at the House of Science and Art in Petrograd (St. Petersburg) on 25 May featured the poet Dmitri Petrovsky and Tatlin discussing 'The Days of Icarus; Modernity as a crucible or foundry; The Route from Space to Time; The Existence of the Mathematical Laws of Time; Khlebnikov's Achievements in [the book] *Time the Measure of the World*; Futurism as a Periscope to What Will Be; Creativity in the Use of Words, The Laws of Language (especially Russian); The Futurists-to-be – the Myth of Theseus and the Minotaur', as well as constructions with materials made by Tatlin and Lev Bruni.

These themes would not interest Marinetti, but they were deeply embedded in the futurist thinking of Tatlin, Malevich, Rozanova, Kamensky, Kruchenykh and Mayakovsky.

DISPERSAL

Futurists scattered by war included Ilya Zdanevich who published Kruchenykh from his new base in Tiflis (Tblisi) in Georgia, where he led the futurist group 41°, exhibited and published *zaum* poetry.

Goncharova and Larionov reached Lausanne in Switzerland by 1915. Here Larionov designed the *Le Bouffon* (*The Fool*) for Diaghilev (performed 1921), evoking with flair a Russia that was disappearing fast. Goncharova and Larionov had become major talents in a culture severed from its roots, as had Diaghilev and

Stravinsky. It did not diminish their creativity, but it did make them largely independent of what was going on in Russia.

Larionov's *Portrait of Stravinsky* marks this moment. The composer's face is assembled from two viewpoints to depict movement. His coloured pens lie on the tabletop. There is an air of gloom and anxiety in the stormy eyes and turned down mouth. The expression is visible too in the photographs of Stravinsky, Diaghilev, Larionov and Goncharova at this time in Lausanne 1916, and when the company reached Rome. Encounters between Italian and Russian futurists were revived in a new context, when Goncharova and Larionov again met Marinetti along with the Italian futurist Prampolini.[88]

Larionov was in Rome on 25 March 1917 and invited to the exhibition 'Russian Artists in Rome'.[89] Stravinsky performed at the Teatro Costanzi on 11 April 1917, and the next day his symphonic poem 'Feu d'Artifice' ('Fireworks') was performed with scenery and lighting by Giacomo Balla, using sculptural shapes moved by concealed figures.

Diaghilev provided a refuge for the pioneer futurists Goncharova and Larionov. He produced *Les Contes Russes*, with Larionov's designs at the Teatro Costanzi, Rome, in April and in Paris on 11 May 1917. But Diaghilev also worked with Italian futurists.

There are photographs of Marinetti, Larionov and Goncharova in Rome behaving amicably like old friends. Their disagreements in Russia seem forgotten. Diaghilev also opened up a vastly powerful new avenue: he employed Pablo Picasso who appears in the same photograph. It must have been unnerving for Goncharova and Larionov to meet, in their own professional territory, the painter whose work they had seen in the Shchukin collection in Moscow and whose cubism influenced Italians and Russians equally.

Apollinaire's article on Goncharova and Larionov was translated into Italian by Nina Antonelli and published in *Radiantismo* (*Rayism*) in Rome, 1917, illustrated with Larionov's *Young Lady in a Café* of 1911, his *Portrait of Natalia Goncharova* of 1912 and Goncharova's *Head of a Clown* of 1912.

Goncharova, the poet Jean Cocteau, Larionov, Picasso and Marinetti were together for Diaghilev's production of the ballet *Parade*, described as 'a realist ballet', with music by the composer Erik Satie, libretto by Jean Cocteau, choreography by Massine and spectacular designs by Picasso. His constructed costumes made it a preposterous and towering masquerade in which it was all but impossible to for these characters to dance. *Victory over the Sun*

already had stiff costumes and radical designs on stage four years earlier in December 1913 [see pp.74–75].

Larionov and Goncharova created a new career at a time of misery across much of Europe, but their innovations were no longer accessible to Russian futurists in Moscow or Petrograd. This division never healed. They had called for a shift to the east. In fact they moved west, and their emigration became permanent.

This did not prevent the creation of brilliant productions. The ballet *Le Bouffant* (*Buffoon*) to Prokofiev's music, and designed by Larionov, opened at the Théâtre de la Gaiété-Lyrique in Paris on 17 May 1921. The next year he designed *Le Renard* (*The Fox*) staged by Diaghilev at the Paris Opéra to music by Stravinsky and choreography by Bronislava Nijinska.

In the ballet *Les Noces* (*The Wedding*), first performed in Paris in 1923, Diaghilev, Goncharova, Stravinsky and Bronislava Nijinska collaborated in an energetic production precisely about peasantry, ritual and myth. This Russia contrasted starkly with the images in the news bulletins.

Other Russian futurists arrived in Paris as circumstances permitted. Ilya Zdanevich, fellow member of the Donkey's Tail group, face-painter with Larionov and Goncharova, and designer of futurist books, arrived in 1921. He published *Le-Dentu Faram* (*Le-Dentu le Phare*, *Le-Dentu as a Beacon*) in Paris in 1923, and worked closely with Sonia Delaunay, who designed and painted her own cover for his book. Together Sonia Delaunay and Ilya Zdanevich introduced anarchic costumes into Paris Dada performances in the early 1920s.

FUTURISM IN REVOLUTION

What of futurism inside Russia? Many futurists did not emigrate. War with Germany ended, for Russia, in 1917, the year of the Tsar's abdication and of the revolution that installed Bolshevik communist rule under Lenin. Only when diplomatic relations were established in 1921 was travel resumed between Russia and Western Europe. When the reality of Soviet power replaced dreams of Old Russia, major futurists enthusiastically embraced the new culture.

Tatlin, for example, used the term futurist after the Revolution. Mayakovsky, poet, playwright, and painter, never ceased to operate as a futurist in the Soviet period. Malevich acknowledged the contribution of futurism. All played vital roles in the early revolutionary years. Yet communist thinking was anathema to the anarchic individualism of futurism, for Soviet art was collective in production, ideological in content and public in expression.

Futurists relished a public spectacle, but ideology was more problematic. Tatlin turned his attention to Lenin's call for Monumental Propaganda. Natan Altman, a key figure in *Komfut* (Communist Futurism) in Petrograd, masked the Alexander Column there with suprematist forms in red and orange, like a fire with red flags flying. Mass events and pageants were organized, designed and decorated. The painter and graphic artist Yuri Annenkov's *Re-enactment of the Storming of the Winter Palace* was held on site in 1918. Agitational boats and trains were organized, decorated, and sent on their propaganda missions.

These public events benefited from the futurists' agitational experience. Their iconoclastic techniques could attack the old regime. Agitation had to sway the masses, and art had a cause to promote. The pre-revolutionary cover design that Rozanova had made for the book *Vzorval'* (*Explodity*) [p.71] showed a futurist orator at a rostrum with fighting erupting all around. By comparison the print *Agitator* by Vladimir Kozlinsky takes the futurist example into the politicized public realm. It moves from the experimental book to public and political imagery for the masses.

Mayakovsky developed aggressive directness in the public delivery of his poetry. He responded with brilliance to the agitational role. After October 1919 he made posters to fill empty shop windows with propaganda images. He dedicated poems to the masses, including the poem '100,000,000'. That futurist hero the New Man was now the worker hero, the commissar, the Bolshevik, the big image of collective man. Mayakovsky knew well that the futurist call for a new vision could be adapted to the Soviet vision. Rejecting the culture of the past also provided common ground between the poet of the people and the ideologist demanding a new culture.

Futurism made headway in the experimental period of the first ten years of Soviet rule, 1917–27. Almost always engaged and political, it was no longer private or elitist and no longer safe from political interference and challenge.

Futurists remained visible though transformed. There were even occasions when Italian futurist elements were visible. A photograph taken on 20 December 1918 in Petrograd shows Tatlin at the unveiling of an impressive new street monument, a visible sign of Tatlin's commitment to the Plan for Monumental

Italo Griselli
Monument to Sofia Perovskaya
1918, Petrograd
medium unknown, probably plaster
height approx. 150 cm
whereabouts unknown, probably destroyed

Propaganda. Also present was Anatoli Lunacharsky, Soviet head of education and culture, who had lived in Italy and knew about Italian futurism. The Italian sculptor Italo Griselli is there beside the colossal head of his *Monument to Sofia Perovskaya* [p.37], revolutionary heroine and the assassin of Tsar Alexander II in 1881. Here in revolutionary Petrograd Tatlin had commissioned an artist who worked with Marinetti and had exhibited with Italian futurists. Griselli's *Monument to Sofia Perovskaya* had the baroque curves of Bernini and Boccioni's sculptures. Here was Russian revolutionary officialdom embracing futurism of the Italian kind.

Tatlin's own response to Monumental Propaganda was his projected *Monument to the Third International*, a perfect example of an art of the future, communal in its development, public in

its expression, designed to be higher than the Eiffel Tower and straddling the River Neva in Petrograd. It was designed to house the government of the Soviet International and ultimately the government of Planet Earth. At the same time it perfectly embodied Russian futurist concepts of time and space, its revolving halls making it a colossal clock. In this giant, mechanized, striding figure Tatlin recognized not an heroic, nor typical, nor an ideal man but the communist image of Communal Man, an image that only the conjunction of Russian futurism and communist government could achieve.

In 1918 Vasili Kamensky and David Burliuk appeared in Mayakovsky's film *Creation Cannot be Bought*, perhaps set in the Stray Dog Cabaret, with Burliuk's paintings on the walls. But in the civil war Burliuk fled east, founded a Russian futurist group in Vladivostok, and another in Japan. After reaching the United States he issued the *Manifesto-Radio-Style* of the Universal Camp of Radio-Modernists from New York in 1926, describing himself as a painter, orator, actor, showman and 'radio-futurist'.

Ideologists replaced dealers in the revolutionary system. The state art exhibitions that replaced commercial enterprise were kind to futurists for several years, but ideology was always there. Osip Brik, friend of Mayakovsky, asked 'if a cobbler makes a shoe and an artist makes a painting – what is the difference?' Boris Kushner, another ideologist, asserted that 'to the socialist consciousness, a work of art is no more than an object, a thing'.[90]

Malevich produced little politicized work. After squeezing out Chagall from the Vitebsk Free Studios, he established the working collective Unovis to develop the potential of suprematism. A third version of *Victory over the Sun* was planned for 1920 with his colleague Vera Yermolaeva. She designed the sets and costumes for the New Man, the futurist Strongman and other characters that seemed, under Soviet power, to be coming to life. These costumes were published in the *Unovis Almanac*, No. 1, 1920, in Vitebsk. Malevich himself developed architectural versions of suprematism in plaster architectural studies (*architectonics*), and his brilliant student and colleague Lazar (El) Lissitzky developed suprematism in lithography, graphic design, painting, photography, exhibition design and architectural projects, as well as through his books and travel.

Lissitzky's collage of *Tatlin Working on the Monument to the Third International* [p.86] picks up themes from *Victory over the Sun*. Tatlin, whose image Lissitzky has drawn from a well-known documentary photograph, is here seen not so much measuring

the struts of his model of the monument, but looking towards the stars. Even Malevich published an article 'On Poetry' in 1919 producing his own *zaum* verse: 'Ule ele lal Ope Kon Si An'.[91] Lissitzky learned to sharpen up, politicize, print and use these insights in his agitational work, suffusing it with futurist energy at the same time. He made *zaum* into a graphic medium with qualities of poetry and architecture. Spreading the words around his best-known poster to say 'Beat the Whites with the Red Wedge' liberated the words. Lissitzky was soon to develop this in the construction of children's books, and books of Mayakovsky's verse. The 'Language of Posters' was the subject of a discussion led by the poet Kruchenykh on 14 September 1921.[92]

But Lissitzky's civil war poster perpetuates an echo of Marinetti's stylized signature in which the sharp point of futurism pierces the yielding curve of the Past. There were still traces of Italian futurism in Russia.

Lissitzky also redesigned *Victory over the Sun*, a fourth revival, as 'an electro-mechanical show'. Here in a multilingual world Soviet New Man strides forward, geometric, anonymous and dynamic, a universal man, constructed from transparent geometry.

When Lissitzky was designing Mayakovsky's book of agitational poems *Left March* (*Levyy Marsh*), published in 1924, the design and layout of the lettering effectively interpreted the content of the poetry on the page as graphic elements used to construct the visual form of the poem. The effect is striking at a distance and close to, legible visually and verbally. It makes the book a kind of construction, derived ultimately from the experiments of the futurists Kruchenykh and Kamensky.

Lissitzky worked efficiently and creatively within the constraints of ideology. This was true of his suprematist book *About Two Squares* [p.110] that linked suprematism, lettering, architecture and cosmology. This embodied well the idea that Malevich had formed as a question in 1920: 'From whose canvases will the plans of new buildings fly?'[93] Lissitzky's later exhibition designs and photography demonstrate how this architectural potential survived in his work.

EXPORT

Lissitzky became a key figure in the export of Soviet achievements in art. He designed the poster and catalogue cover for the 'First Russian Art Exhibition' ('Erste Russische Kunstaustellung') that opened at the Galerie Van Diemen in Berlin in 1922. Exhibitors included Altman, David Burliuk (*Portrait of Kamensky*), Chagall, Ermolaeva (two costumes for *Victory over the Sun*), Exter, Filonov, Kandinsky, Kozlinsky, Kulbin, Gabo, Le-Dantyu, Lissitzky, Malevich, Mayakovsky (a poster *Revolution in Russia*), Pevsner, Popova, Puni, Rodchenko, Rozanova (14 works), Stepanova, Tatlin and Yakulov.

Exter moved to Paris in 1924, transferring there her skills in costume and set design previously employed at the Kamerny (Chamber) Theatre in Moscow under its director Alexander Tairov. She had just designed Martian sets and costumes for the Soviet film *Aelita* about revolution on the planet Mars [pp.94–95; see also p.39].

Rodchenko and Stepanova also had a special relationship with futurist ideas. A photograph taken in Stepanova's studio was deliberately posed in the manner of the photographs taken at the time of *Victory over the Sun*. After nine years, Rodchenko and Stepanova inverted their own furniture for the photograph. A large light bulb is inserted into an upturned chair. Rodchenko was paying his respects to the futurists whom he first saw in Kazan on their tour in 1914. Rodchenko was still exploring their vision of time and space.

Rodchenko also worked closely with Mayakovsky who was composing rhymes for Soviet advertising, promoting galoshes, cigarettes and the Moscow state-run universal store Mosselprom. Rodchenko devised the designs for Mayakovsky's texts and for his plays.

In 1925 they both travelled to Paris for the Soviet Pavilion at the International Exhibition there. The wooden pavilion designed by the architect Konstantin Melnikov comprised two wedge-shaped halves interlocking in a diagonal symmetry [p.91]. These diagonals ultimately had their origin in the rayism of Goncharova and Larionov, and their subsequent development in the architectonic compositions of Lyubov Popova and Alexander Vesnin. Here they structure the plan and elevation of the building. Melnikov adapted their dynamic energy to represent the dictatorship of the proletariat, set provocatively among the fashionable elegance of Paris. The stairs in Melnikov's pavilion progressed diagonally from corner to corner leading to the first floor display room. Slotted roof panels overhead sustained the complex symmetry, joining the two halves as they rose like triumphal trumpets in opposite directions. Among the fashion houses, this Soviet Pavilion became

Alexandra Exter
Still from the film *Aelita*, 1924
Director: Iakov Protozanov
National Film Archive

an agitational object, a propaganda kiosk. It was the first and last architectural example of Russian futurism seen in Western Europe.

Mayakovsky visited the Delaunays in Paris and painted a sun on one of their doors in recognition of their friendship and their importance for Russian futurism. But Paris had changed, and the heady cubist days of 1910–14 were lost beyond a gulf of war, revolution and ideology.

As for Italian-Russian contacts, they too became politically fraught in the post-war years. There was a curious event, however, at the Venice Biennale in 1926 when, as the exhibition catalogue records, the Soviet Pavilion 'was graciously conceded to the exhibition of Italian futurism under the curatorship of F.T. Marinetti', but, as the catalogue shows, no Russians appeared among the sixty futurist works by Balla, Boccioni, Depero, Dottori, Prampolini, Russolo and others.

Diaghilev, of all people, turned to futurists to design the ballet *Le Pas d'Acier*, performed to Sergei Prokofiev's score. The Georgian futurist Georgiy Yakulov and the Italian futurist

Fortunato Depero designed and constructed the sets and costumes. It opened at the Théâtre Sarah Bernhardt in Paris on 7 June 1927. The ballet contrasted the stories and legends of the countryside with the mechanized world of the industrial factory, a perfect way for two futurist movements to end the love-hate relationship of their fierce and creative competition.

POSTSCRIPT

The revival of interest in Russian futurism coincided with the rediscovery of the Russian avant-garde in Western Europe in the 1960s. This intense interest can be seen from the growth of publishing in this field after that time. Even so, attempts to distinguish Russian futurism from constructivism, suprematism, and so on, were rare.

Commentators and historians were so eager to distinguish uniquely Russian features of these movements that they may have underestimated the debt to Italian futurism.

The Western interest was also, to a degree, driven by gallery exhibitions and by sales. These valuable initiatives discovered and exhibited much that would otherwise have remained obscure and even forgotten.

The collector Eric Estorick played a particular role in this context through his enthusiasm for both Russian and Italian twentieth century art. He owned Larionov's *Quarrel in a Tavern* [p.44] that hangs in the present exhibition, David Burliuk's *Sailor of the Siberian Fleet* and several important works by El Lissitzky, including *Tatlin Working on the Monument to the Third International* that is also here [p.86].

The collector's perspicacious eye had a role in recognizing the importance of these works. In his memoirs, Eric Estorick was careful to acknowledge the achievement of the collector George Costakis in assembling works of the Russian avant-garde in his Moscow apartment. That collection changed the history of the subject, and so it is especially satisfying to have loans from the Costakis Collection in the present exhibition.

This is a rare chance to exhibit Russian and Italian futurist works *together* in the gallery established in Eric Estorick's name.

When Russian futurists launched their works in their own day, they were confident of their trajectories into future time and space. Their works have arrived as fresh, radical and dynamic in the twenty-first century as they were when first they were launched.

NOTES

1 Giovanni Lista (ed.), *Marinetti et le Futurisme – études, documents, iconographie* (Lausanne, L'Age d'homme, 1977), p. 129.

2 D. Burliuk, N. Burliuk et al., *Poshchechina obshestvennoy vkusu* (*A Slap in the Face of Public Taste*), (Moscow, G.L. Kuzmin, 1912). See Susan Compton, *The World Backwards* (London, British Library, 1978).

3 Exhibition catalogue, *IV Biennale de Venezia* (Venice, 1901), p. 23.

4 Gino Agnese, *Vità di Boccioni* (Florence, Camunia, 1996), p. 109.

5 He went to Kazakhstan on 6 September, visiting Kalmyk yurts on the Steppes. See Agnese, 1996, pl. 11.

6 Ester Coen, *Boccioni* (New York, Metropolitan Museum of Art, 1989), p. 28.

7 Lista, 1977, p. 138.

8 See Agnese, 1996, pp. 109ff.

9 Agnese, 1996, p. 67.

10 Agnese, 1996, p. 120.

11 Presumably using works shown at the Salon d'automne in Paris in the previous year.

12 *VII Biennale di Venezia, 1907*, exhibition catalogue (Venice, 1907).

13 See D. Chadd and J. Gage, *The Diaghilev Ballet in England* (Norwich University of East Anglia, 1980), p. 13.

14 Boccioni lived at Calle della Fava 5601, San Salvatore, Venice. See Coen, 1989, p. 28.

15 See Coen, 1989, p. 28

16 See Vladimir Markov, *Russian Futurism – A History* (London, Macgibbon and Kee, 1969), p. 148, which refers to an article in the newspaper *Vecher* (Evening) reporting Marinetti's ideas on 8 March 1909.

17 *Apollon*, nos. 5–9, 1910. See, for example, 'Pisma iz Italii' in *Apollon*, no. 9, 1910, pp. 1–18, and Markov, 1969, p. 148.

18 See Chadd and Gage, 1980, p. 13. This combination of myth and vitality occurs, for example, in the Polovtsian Dances set into Borodin's *Prince Igor*.

19 Roerich and Stravinsky worked together on this at Princess Tenisheva's estate near Smolensk. See David Chadd and John Gage, *The Diaghilev Ballet in England*, exhibition catalogue (Norwich, The Sainsbury Centre, 1979), p. 22. Stravinsky in collaboration with the painter and scholar Alexandre Benois designed the ballet *Petrushka*, which also celebrated folk cultures. This production opened in Paris on 13 June 1911 at the Théâtre du Châtelet. See Lynn Garafola and Nancy Van Norman Baer, *The Ballets Russes and its World* (New Haven and London, Yale University Press, 1999), p. 326.

20 Lista, 1977, gives the dates as 5–24 February 1912. See also Agnese, 1996, p. 257, note 4. See also Maria Drudi Ganbillo and Teresa Fiori, *Archivi del Futurismo* (Rome, De Luca, 1986), vol. 1, p. 235.

21 However, the Russian futurist writer Benedikt Livshits maintained that David Burliuk had seen no Italian futurist works – not even in reproductions. See Wiktor Woroszylski, *The Life of Mayakovsky* (London, Victor Gollancz, 1972), p. 42.

22 Woroszylski, 1972, pp. 42–43.

23 Woroszylski, 1972, pp. 42–43.

24 Aspects of Delaunay's 'Orphism', launched in 1912, reflected a comparable interaction of sun and moon. For technical details about the eclipse see: www.imcce.fr/eclipse99/eclipse/12_eng.html.

25 V. Katanyan, *Mayakovsky* (Moscow 1961), p. 43. Present author's translation. Chagall too made wordplay about his name. In Russian *shag* means step. These appear, for example, as footsteps in the snow in certain works.

26 *Soyuz Molodezhi*, no. 2, 1912, pp. 23–35. See Markov, 1969, p.148, and Nina A. Gurianova, *Exploring Color: Olga Rozanova and the Early Russian Avant-Garde 1910–1918*, translated by Charles Rougle (Amsterdam, G and B Arts International, 2000), pp. 142–143.

27 Woroszylski, 1972, p. 44.

28 D. Burliuk, N. Burliuk et al., 1912.

29 D. Burliuk, N. Burliuk et al., 1912. See also Woroszylski, 1972, p. 47.

30 Woroszylski, 1972, p. 48.

31 A. Kruchenykh and V. Khlebnikov, *Mirskontsa* [*Worldbackwards*], illustrated by N. Goncharova, M. Larionov, I. Rogovin, (Moscow, G.L. Kuzmin and S.D. Dolinsky, 1912).

32 Woroszylski, 1972, p.48

33 This is cited from A. Kruchenykh 'Nash Vykhod. K istorii russkogo futurizma' in Nina Gurianova (ed.) *Iz literaturnogo naslediya Kruchenykh: pamyat' teper' mnogoe razvorachivaet* (Berkeley, University of California Press, 1999), p. 65. This source is discussed further in N. Gurianova 2000, pp. 146–147.

34 N. Gurianova, 2000, p. 146.

35 Duchamp was an advisor to the Société Anonyme collection working with Katherine Dreier. When the collection acquired Malevich's *Knifegrinder*, Duchamp must have recognized the homage Malevich had paid to him. The collection of the Société Anonyme was subsequently transferred to Yale University Art Gallery.

36 Eli Eganbyuri [Ilya Zdanevich], *Nataliya Goncharova Mikhail Larionov*, (Moscow, Myunster, 1913).

37 Mikhail Larionov, *Luchizm*, cited in Gurianova, 2000.

38 Tasteven published his book *Futurizm* in 1914. Sillart wrote about Boccioni in *Apollon*, no. 7, September 1913, pp. 61–63. For information on Russian reports about Marinetti see Markov, 1969, p. 401, notes 79–84.

39 R.W. Flint. *F.T. Marinetti: Selected Writings* (London, Secker and Warburg), p. 343.

40 See Woroszylski, 1972, pp. 55–58.

41 Kamensky, cited in Woroszylski, 1972, p. 55

42 Kamensky, cited in Woroszylski, 1972, pp. 56–57.

43 See Kurbanovsky in Petrova, 2003, p. 51, where it is also suggested that some Malevich drawings illustrate figures of speech and metaphors literally. Malevich's painting *Woman at a Poster Column* (1914, Stedelijk Museum, Amsterdam) and the related drawing (in John Milner, *Malevich and the Art of Geometry*, Yale University Press, New Haven and London, 1996, pl. 174) which both incorporate the Cyrillic letters ОВР (OVR in Latin script) should therefore refer to Olga V. Rozanova.

[44] Kamensky, cited in Woroszylski 1972, pp. 55–56

[45] V. 'Futuristicheskaya Muzyka' in *Moskovskaya Gazeta*, 7 October 1913, no. 227, p. 2. I am indebted to Dr Sarah Dadswell at Exeter University who generously provided a copy of this and several other newspaper articles.

[46] There may be other word games here. Pike (Пик), in Russian, like pike in English, can mean a fish or a weapon. In French (*piques*) and in Russian it also means the suit of spades in playing cards, and may also relate to the name Picasso spelled with a K in Russian. Пиль (Pil') is a saw, so these are perhaps fragmented words here. The Ш (sh) sound occurs in words associated with the sword: Шпага (*Shpaga*, rapier, sword), or Штык (*Shtyk*, bayonet).

[47] These quotations are from Woroszylski, 1972, pp. 62–64.

[48] See Gurianova, 2000, note 48.

[49] Shklovsky, cited in Woroszylski, 1972, p. 61. See also Compton, 1978, p. 49.

[50] Cited in Compton, 1978, p. 57.

[51] See Markov, 1969, p. 145.

[52] See Woroszylski, 1972, p. 55. For a list of publications by Ilya Zdanevich see Markov, 1969, p. 440.

[53] Cited in Gurianova, 2000, p. 150. Mayakovsky performed there several times, after his first appearance in mid-November 1912.

[54] Anthony Parton, *Mikhail Larionov and the Russian Avant-Garde* (Princeton, Princeton University Press, 1993), p. 72.

[55] In 1914 Livshits argued with Marinetti and claimed that Yakulov had developed comparable Sun motifs a year ahead of Delaunay's *Simultanéisme*. See Vahan D. Barooshian, *Russian Cubo-futurism 1910–1930* (The Hague and Paris, Mouton, 1974), p. 151.

[56] Flint, 1972, p. 345. The Italian Sibilla Aleramo published an article on Italian Futurism in the journal *Russkaya mysl'* (*Russian Thought*) in December 1913. This is discussed in Markov, 1969, p. 148

[57] D.S., 'Gotovyatsya' in *Rannee utro*, 25 January 1914, no. 20, p. 4. I am indebted to Dr Sarah Dadswell at Exeter University who generously provided a copy of this newspaper article.

[58] 'Priezd Marinetti' in *Rannee utro*, 28 January 1914, no. 22, p. 5. Dr Sarah Dadswell Archive.

[59] Ave, 'Marinetti o Futurizme' ('Marinetti on Futurism') in *Rannee utro*, 28 January 1914, no. 22, p. 5. Dr Sarah Dadswell Archive.

[60] See Markov, 1969, p. 148 and note 52.

[61] The film was 431 metres long. For full discussion see Parton, 1993, p. 71.

[62] Discussed in Woroszylski 1972, p. 93, in Lista, 1977, p. 129, and in Parton 1993, p. 73.

[63] Lista, 1977, p. 130. See also Woroszylski 1972, p. 95.

[64] 'Lektsiya F.T. Marinetti' ('Marinetti's Lecture') in *Rannee utro*, 28 January 1914, no. 22, p. 5. Dr Sarah Dadswell Archive.

[65] 'Marinetti v Moskve' ('Marinetti in Moscow') in *Rannee utro*, 29 January 1914, no. 23, p. 5. Dr Sarah Dadswell Archive

[66] See Flint, 1972, pp. 356–357, and Parton, 1993, p. 73.

[67] See C. Salaris, *F.T. Marinetti*, (Florence, La Nuova Italia, 1988), p. 130, plate 182, and also Flint 1972, p. 347.

[68] 'Lektsiya F.T. Marinetti' in *Rannee utro*, 31 January 1914, no. 25. Dr Sarah Dadswell Archive.

[69] Flint, 1972, p. 358.

[70] Matiushin's recollection is recounted by Gurianova, from Mikhail Matiushin *Russkie Kubo-Futuristy*, p. 154. See also Woroszylski 1972, p. 94. Marinetti performed his poem *Zang. Tumb Tumb*. See Markov, 1969, p. 15.

[71] Woroszylski, 1972, p. 94. Livshits was unable to persuade Marinetti of Khlebnikov's importance in this respect. Discussed in Markov, 1969, pp. 154–156, and given verbatim in Barooshian, 1974, p. 148–151.

[72] Flint, 1972, p. 349

[73] Flint, 1972, p. 349

[74] Flint, 1972, pp. 354–355. Vadim Shershenevich published Marinetti's *Bitva v Tripoli* ('Battle of Tripoli') in Moscow in 1915, and his book *Futurist Mafarka* in Moscow in 1916.

[75] Woroszylski, 1972, p. 58. Olga Rozanova in her essay 'Cubism, Futurism, Suprematism' described 'the savage happily drawing the outlines of a bull or a deer on a piece of stone, the primitivist …and even to some degree the Futurists are all united by the same thing, the object' (article prepared for *Supremus* periodical, No. 1, Moscow, 1917), translated by John E. Bowlt in the exhibition catalogue *From Painting to Design* (Cologne, Galerie Gmurzynska, 1981), p. 100.

[76] Woroszylski, 1972, p. 95.

[77] Woroszylski, 1972, p. 98. The Italian Futurist periodical *LACERBA* had discussed Russian Futurism on 1 April 1914, two days before the exhibition. Popova was to refer to *LACERBA* in several of her paintings of 1914.

[78] *Archivi del futurismo*, vol. 1, (Coedizioni S.P.E.S. Salimbeni, Florence, 1980), p. 322–323.

[79] See Gurianova, 2000, p. 152.

[80] Jessica Boisel (ed.), *Nathalie Gontcharova et Michel Larionov* (Paris, Éditions du Centre Pompidou, 1995), p. 247.

[81] David Burliuk, letter to Andrei Shemshurin, 1914. Cited in Gurianova, 2000, p. 152.

[82] David Burliuk and Vasili Kamensky invited Maxim Gorky to the launch of the miscellany *The Archer* at the Stray Dog Cabaret on 28 February 1915. Gorky's comments were published in his article 'On Futurism' in the *Journal of Journals* (*Zhurnal zhurnalov*), no. 1, 15 April 1915. He said that 'In Russia there is doubtless no genuine futurism, such as came into existence in Italy, embodied in the person of Marinetti'; cited in Woroszylski, 1972, p. 149.

[83] Malevich, letter to Matiushin, late May 1915. See Kovtun, 1981, p. 235.

[84] Discussed in Nina Gurianova, 'The Supremus "Laboratory House". Reconstructing the Journal' in Petrova, 2003, p. 11.

[85] Letter from Malevich to Matiushin, late May 1913, cited by Nina Gurianova in Petrova 2003, p. 11. See Kovtun, 1981, p. 235.

[86] Alexei Kurbanovsky, 'Kazimir Malevich and Aspects of Early Twentieth Century European Theoretical Thought', in Yevgenia Petrova (ed.), *The Russian Avant-Garde: Personality and School* (St. Petersburg, Palace

Editions, 2003), p. 49.

[87] *Apollon*, January 1916, no. 1, p. 37. The article also deplored the 'ungrammatical arithmetic' of the exhibition's name. The '0,10' of the exhibition's name probably refers to the ten exhibitors.

[88] See Pincus Hultén, *Futurismo and Futurismi*, (Venice, Palazzo Grassi, 1986), p. 499.

[89] The exhibition was at the Literary Circle in Via delle Colonnette, Rome, from 25 March 1917. The invitation card is in the collection of the Victoria and Albert Museum, National Art Library, London.

[90] Boris Kushner, 'The Divine Work of Art' (*Bozhestvennoe proizvedenie*) in *Iskusstvo Kommuny*, no. 9, 2 February, 1919, p. 1. See John E. Bowlt (ed.), *Russian Art of the Avant-Garde: Theory and Criticism 1902–34* (New York, Viking Press, 1976), p. 170.

[91] K. Malevich 'O Poeziy' ('On Poetry') in *Izobrazitel'noe iskusstvo* (*Plastic Art*), no. 1, 1919.

[92] See V. Katanyan, *Mayakovsky* (Moscow, 1961).

[93] Cited in Vasili Rakitin, 'Malevich after Anarchism' in Petrova, 2003, pp. 27–28.

FURTHER READING

Susan Compton, *The World Backwards. Russian Futurist Books 1912–16*, (London, The British Library, 1978)

Nina Gurianova, *Explaining Color: Olga Rozanova and the Early Russian Avant-Garde 1910–18*, trans. Charles Rouble (Amsterdam, G&B Arts International, 1999)

Peter Hellyer, *A Catalogue of Russian Avant-Garde Books 1912–1934 and 1969–2003* (London, The British Library, 2006)

Anna Lawton and Herbert Eagle (trans. and eds.), *Words in Revolution: Russian Futurist Manifestoes 1912–1928* (Washington, New Academia Press, 2005)

Vladimir Markov, *Russian Futurism: A History*, with an introduction by Ronald Vroon (Washington, New Academia Press, 2006)

Anthony Parton, *Mikhail Larionov and the Russian Avant-Garde* (Princeton, Princeton University Press, 1993)

Yevgenia Petrova, *Russian Futurism* (St. Petersburg, Palace Editions, 2000)

Yevgenia Petrova, *The Russian Avant-Garde: Representation and Interpretation* (St. Petersburg, State Russian Museum/Palace Editions, 2001)

A.D. Sarab'yanov and N.A. Guryanova, *Neizvestnyy Russkiy Avangard v muzeyakh i chastnykh sobraniyakh* (Moscow, Sovetskiy Khudozhnik, 1992)

Jane Sharp, *Russian Modernism between East and West: Natalia Goncharova* (Cambridge, Cambridge University Press, 2006)

Deborah Wye, *The Russian Avant-Garde Books 1910–1934 (*New York, Museum of Modern Art, 2002)

Umberto Boccioni
*Study for 'Empty and
Full Abstracts of a
Head'*
1912
ink, black wash and
pencil on paper
56.5 x 44 cm
Estorick Collection
London

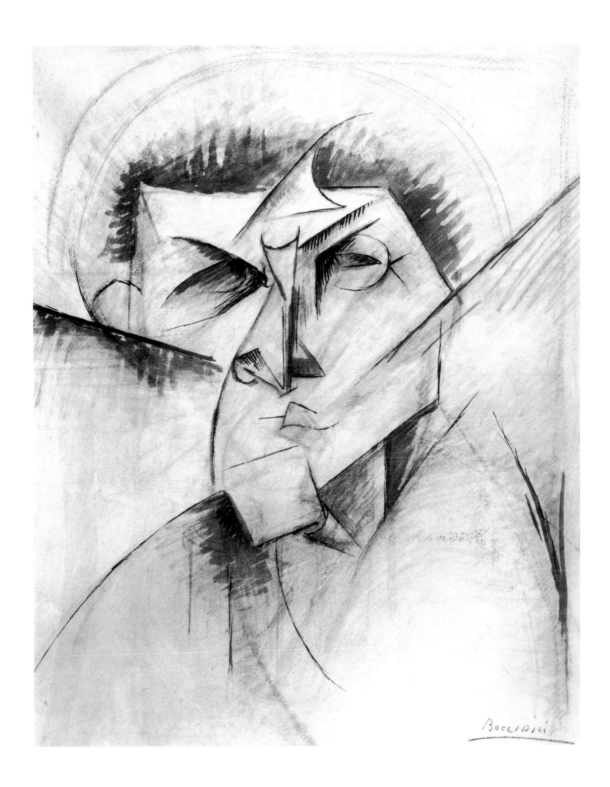

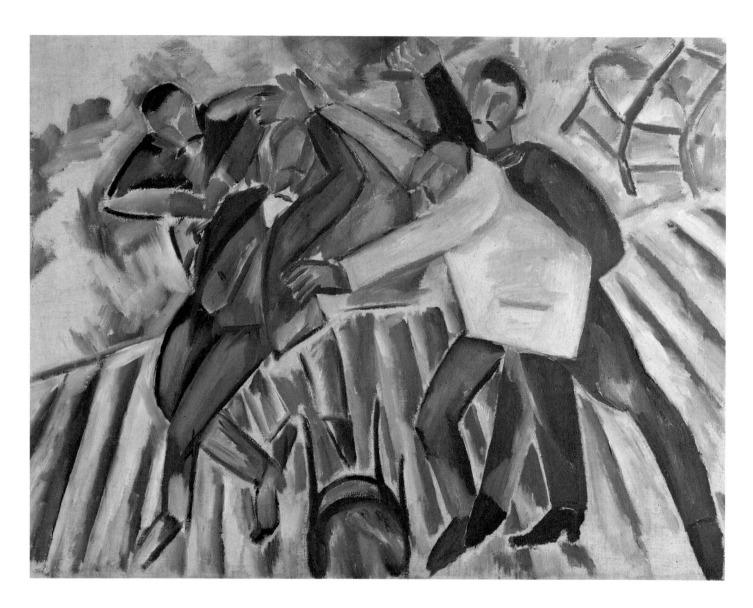

Mikhail Larionov
Quarrel in a Tavern
1911
oil on canvas
72 x 95 cm
Thyssen–Bornemisza Collections

Carlo Carrà
Boxer
1913
ink, charcoal and pencil
on paper
44 x 28 cm
Estorick Collection
London

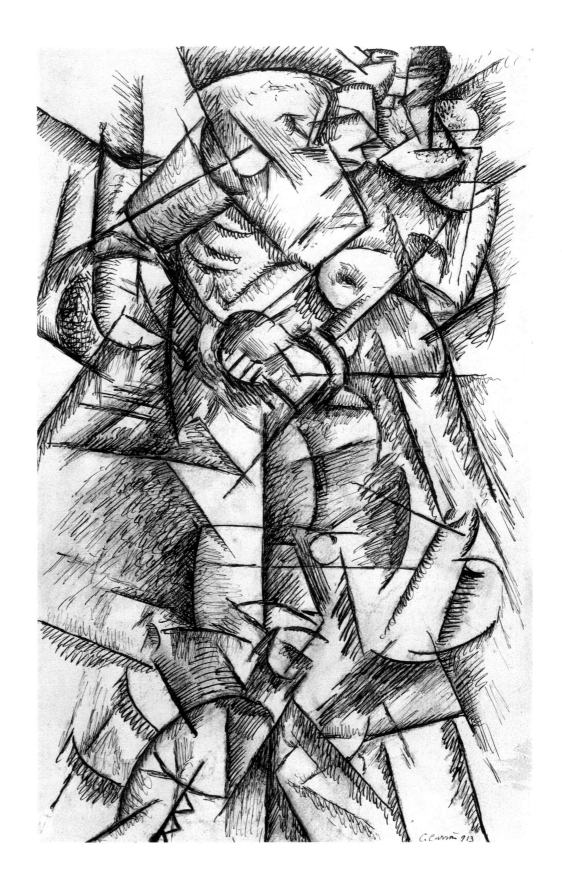

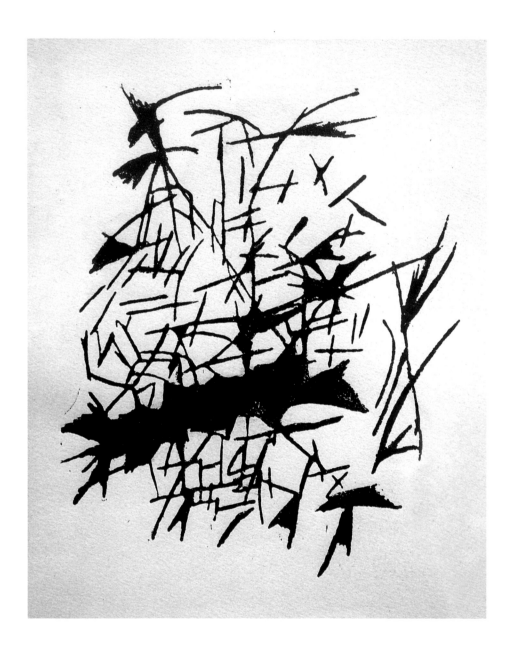

Mikhail Larionov
Rayist Portrait of Natalia Goncharova
from *A Trap for Judges II*
1913
woodcut
18.5 x 15.4 cm
Private collection

Natalia Goncharova
The Forest
1913
oil on canvas
130 x 97 cm
Museo Thyssen-Bornemisza, Madrid

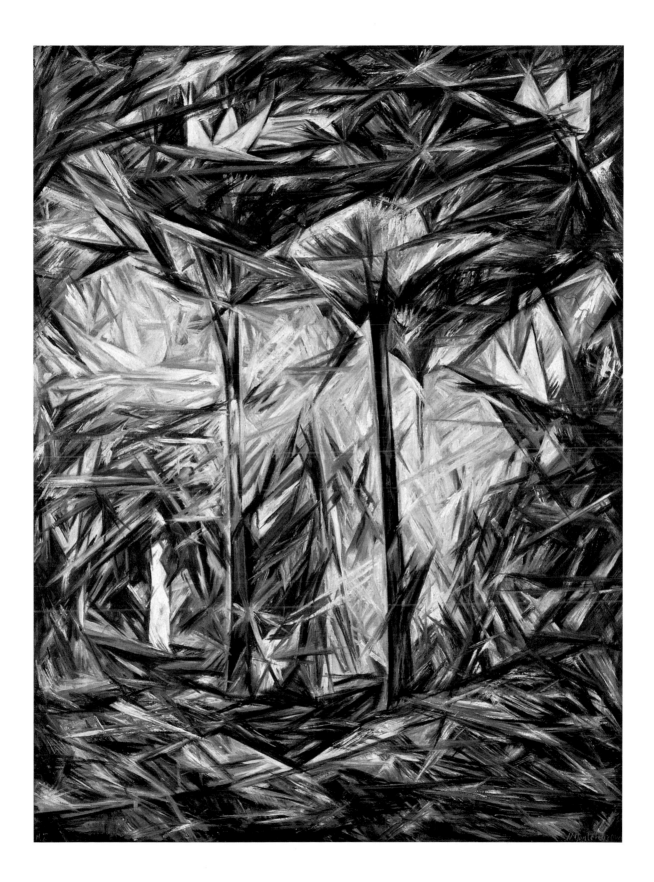

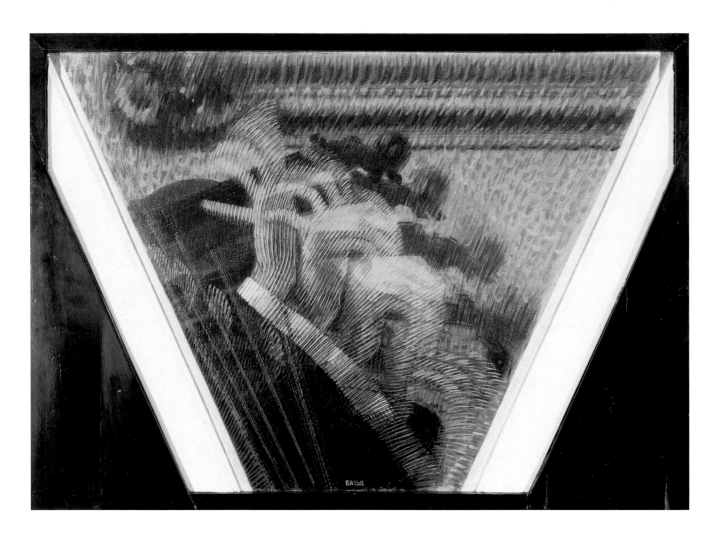

Giacomo Balla
The Hand of the Violinist
1912
oil on canvas
56 x 78.3 cm
Estorick Collection, London

Kazimir Malevich
Cubist Still Life
1913
oil on paper
mounted on board
55 x 48 cm
Private collection, courtesy
of Grosvenor Gallery

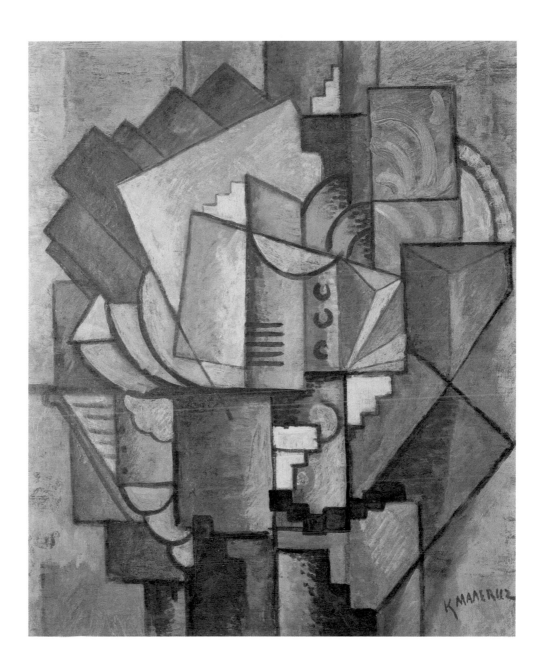

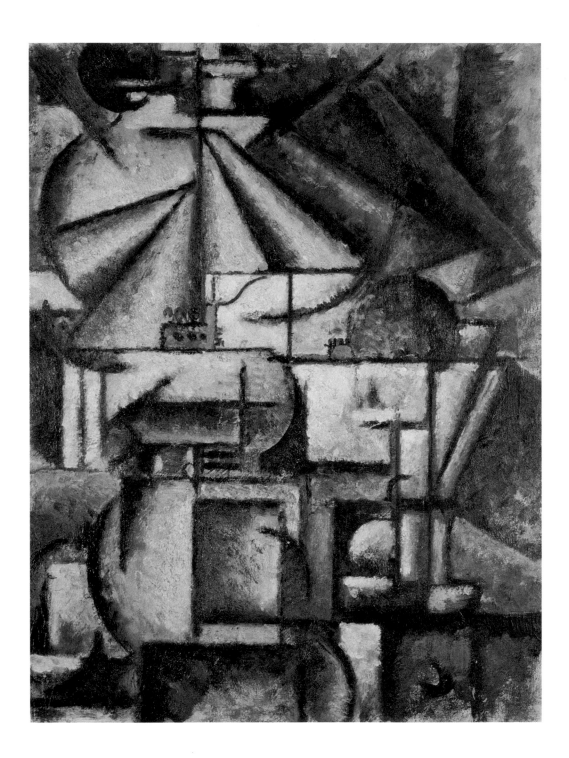

Ardengo Soffici
Deconstruction of the Planes of a Lamp
1912–13
oil on board
45 x 34 cm
Estorick Collection
London

Ivan Kliun
Pitcher, Glass and Bottle
(Cubist Composition)
c.1920
oil on canvas
80 x 50 cm
Private collection

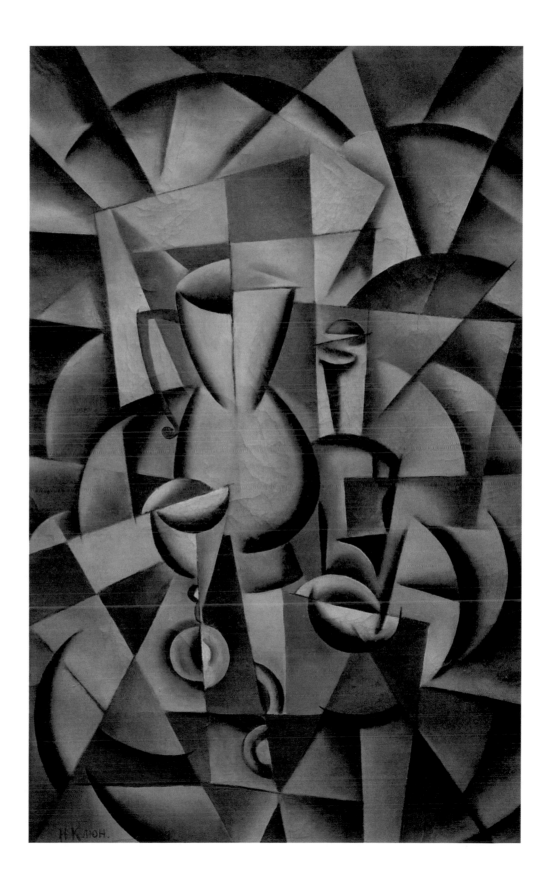

Fernand Léger
Contrast of Forms;
Carriage / Travelling Kitchen
c.1915
ink and gouache on paper
22 x 14.5 cm
Grosvenor Gallery

Inscribed: 'To Larionov and to
Goncharova, to the two great Russian
artists. Their admirer and friend,
F. Léger'

Lyubov Popova
Portrait
1914–15
oil on paperboard
59.5 x 41.6 cm
State Museum of
Contemporary Art
The G. Costakis
Collection

Ivan Kliun
*Self Portrait with
Bottle of Wine*
1914
oil on cardboard
61 x 45.5 cm
Private collection

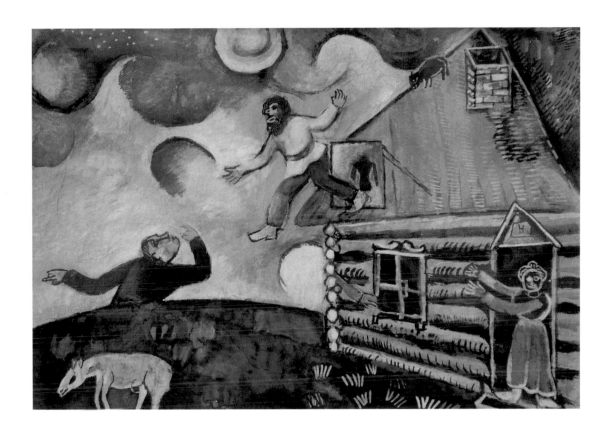

Marc Chagall
The Welcome
1911
gouache on paper
18.5 x 27.5 cm
Private collection, London

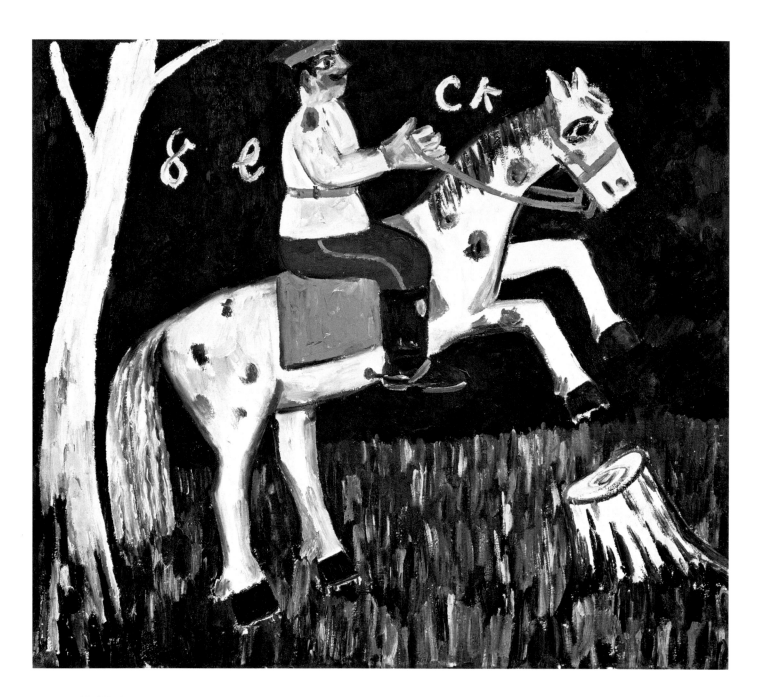

Mikhail Larionov
Soldier on a Horse
c.1911
oil on canvas
87 x 99.1 cm
Tate
Presented by Mme Alexandra Larionov, the artist's widow, 1965

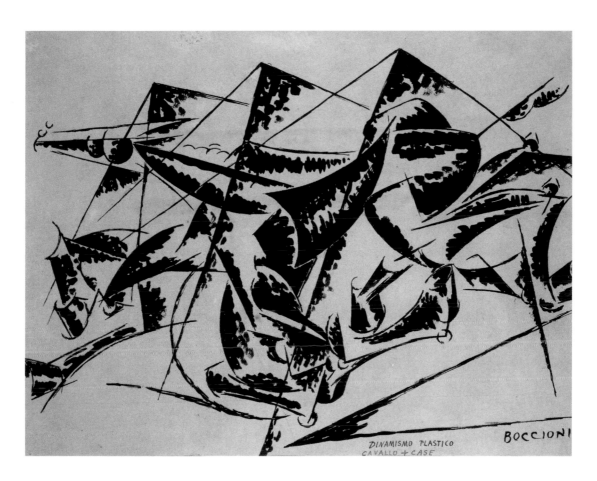

Umberto Boccioni
Plastic Dynamism: Horse + Houses
1914
ink on paper
32 x 41.6 cm
Estorick Collection, London

58

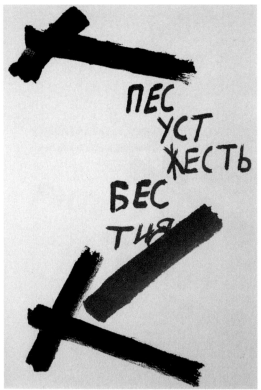

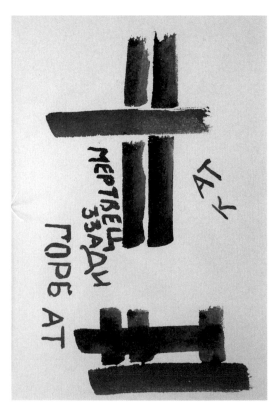

Varvara Stepanova
pages from
Gift – Poison
1919
Private collection

Mikhail Larionov
Spring
1912
oil on canvas
86.5 x 68.2 cm
Centre Pompidou, Paris
Musée national d'art
moderne/Centre de
création industrielle

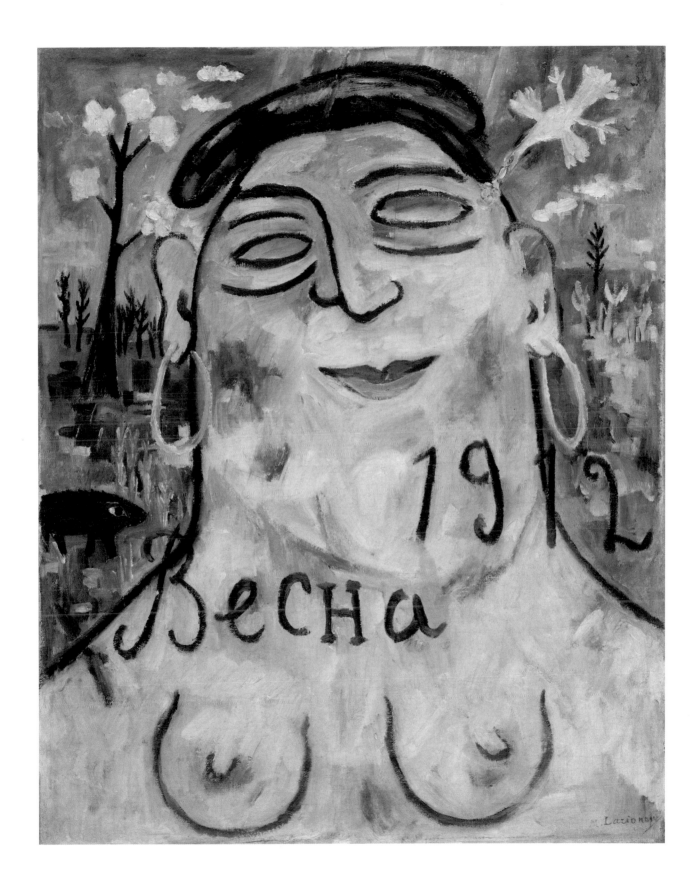

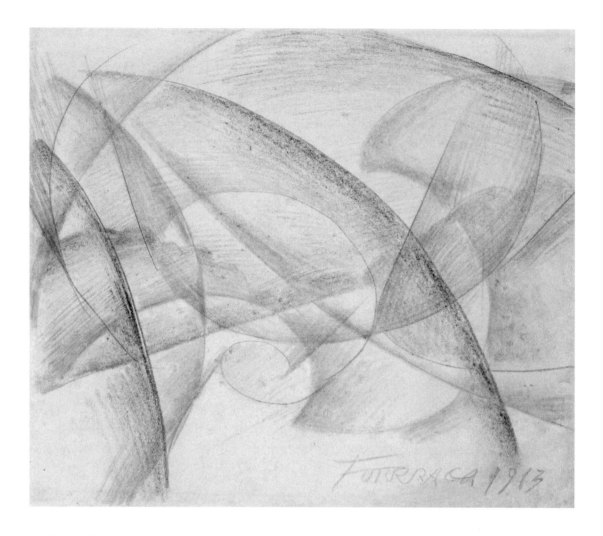

Giacomo Balla
Speeding Automobile
1913
coloured pencils and pencil on paper
25 x 28.5 cm
Estorick Collection, London

Natalia Goncharova
Abstract Still Life / Rayist Still Life
1915–17
oil on canvas
65 x 54 cm
Private collection, London

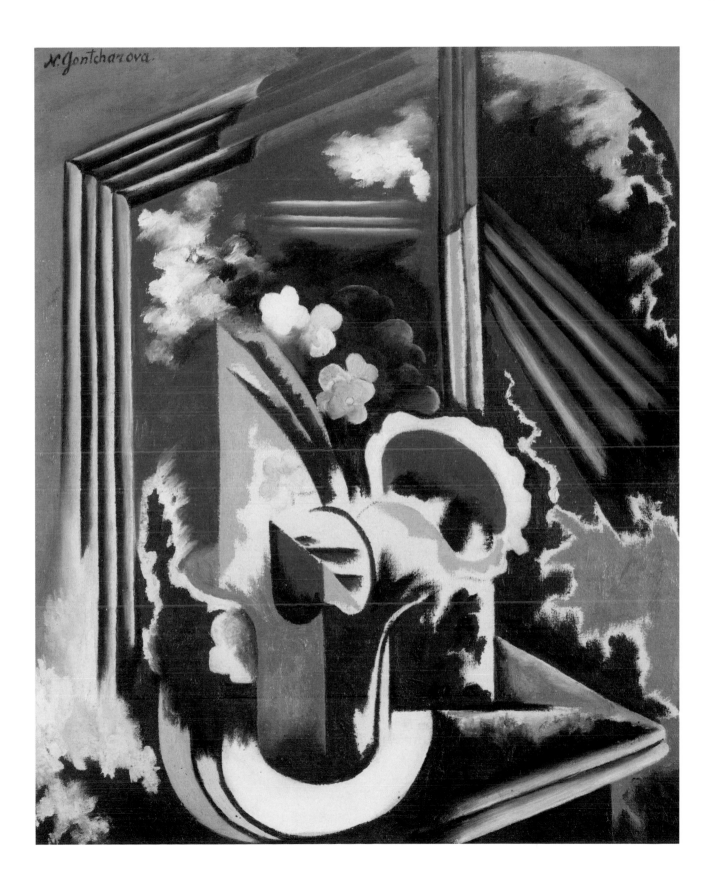

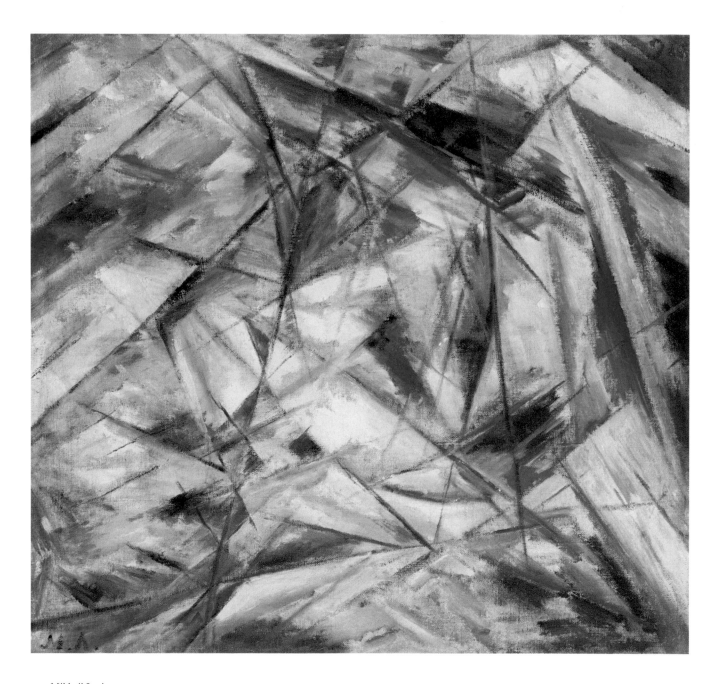

Mikhail Larionov
Blue Rayism
1912–13
oil on canvas
65 x 70 cm
Private collection, London

Gino Severini
Dancer (Ballerina + Sea)
1913
oil, gouache, black wash and
pastel on board
75.5 x 50.5 cm
Estorick Collection, London

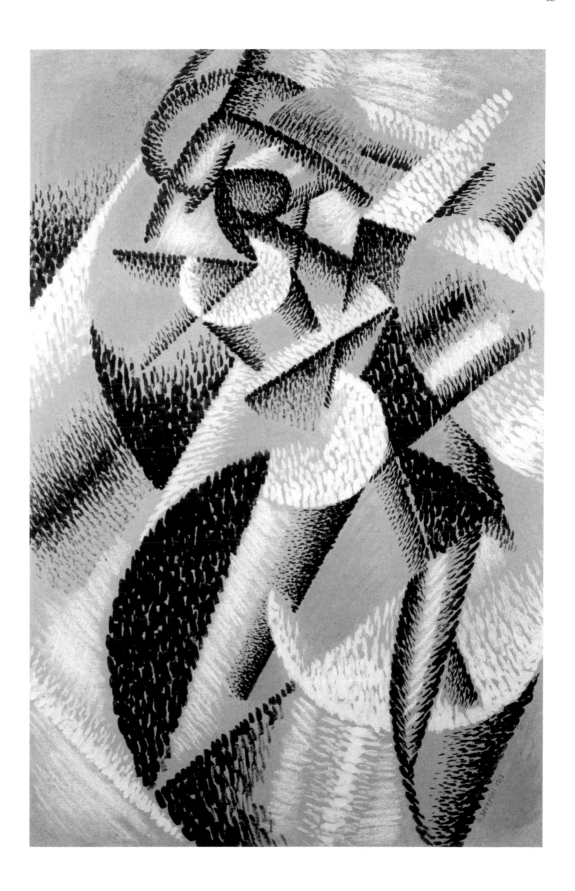

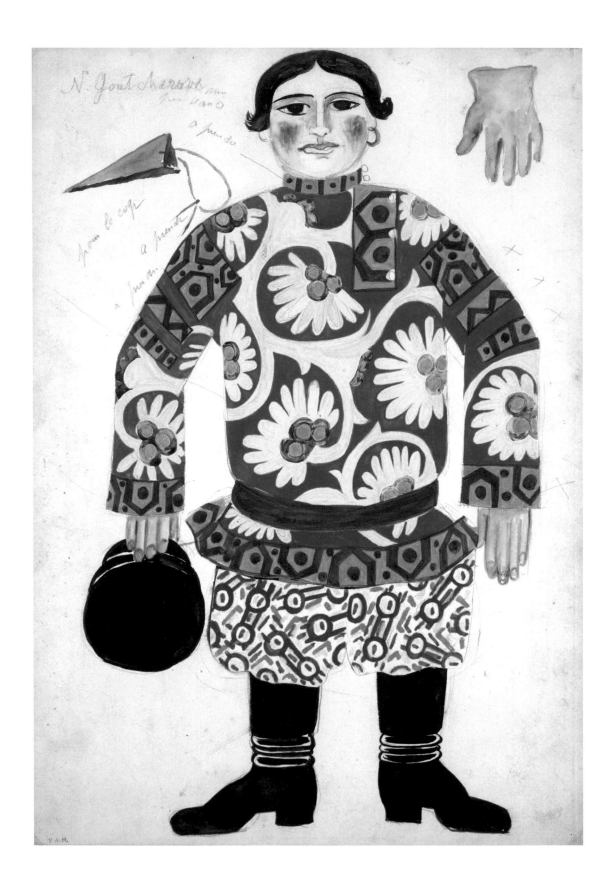

Natalia Goncharova
Costume design for
Le Coq d'or
1914
watercolour on paper
52 x 37 cm
Victoria and Albert
Museum

Natalia Goncharova
Costume design for
Le Coq d'or
1914
watercolour on paper
38 x 26.5 cm
Victoria and Albert
Museum

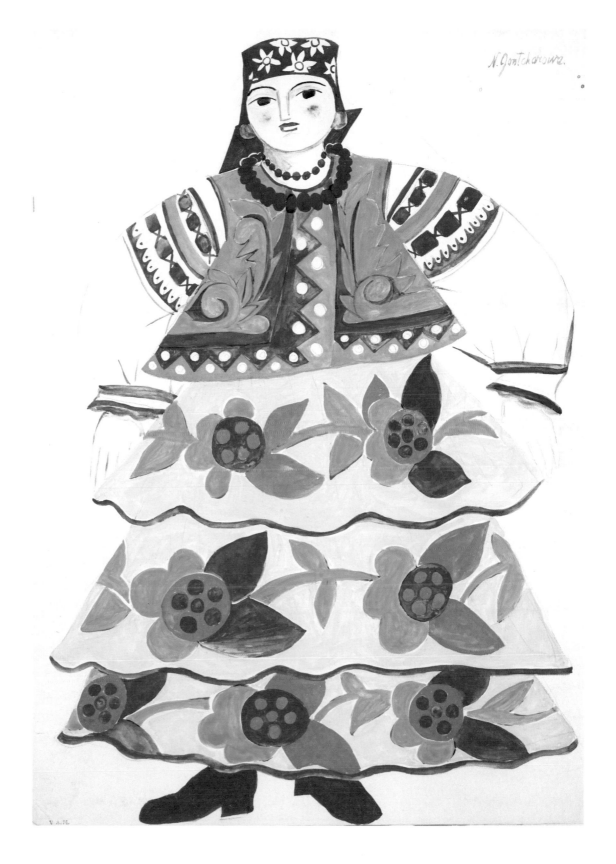

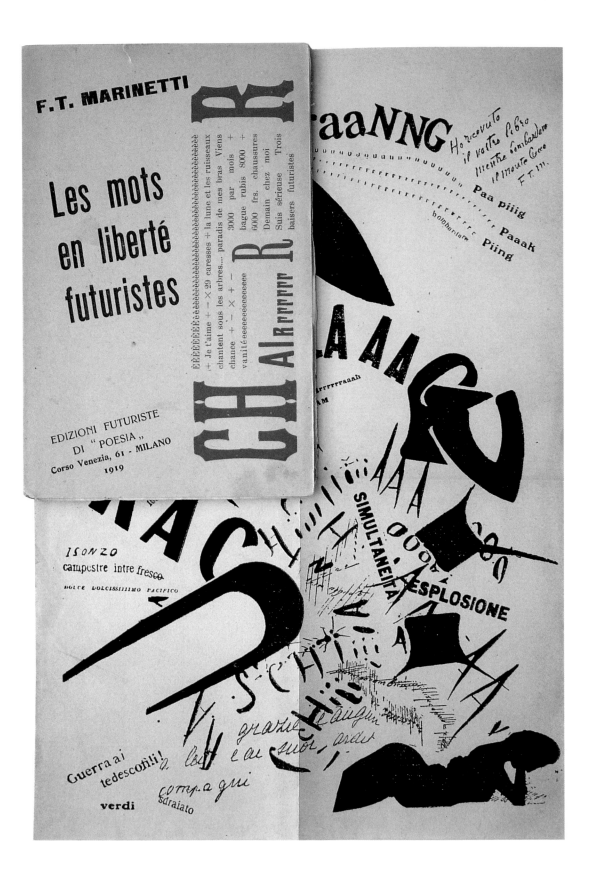

F.T. Marinetti
Futurist Words in Freedom
1919
Private collection

Alexei Kruchenykh and
Velimir Khlebnikov
A Game in Hell
1912
Cover illustration by
Natalia Goncharova
The British Library

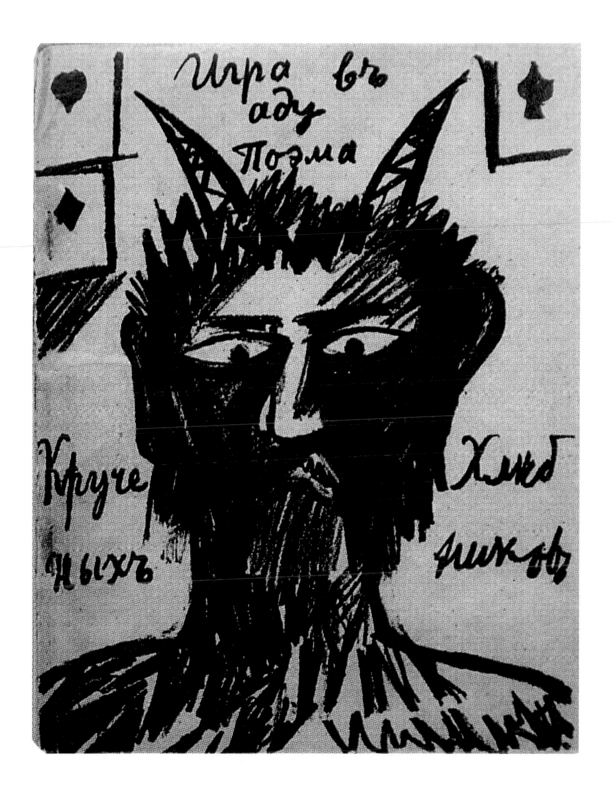

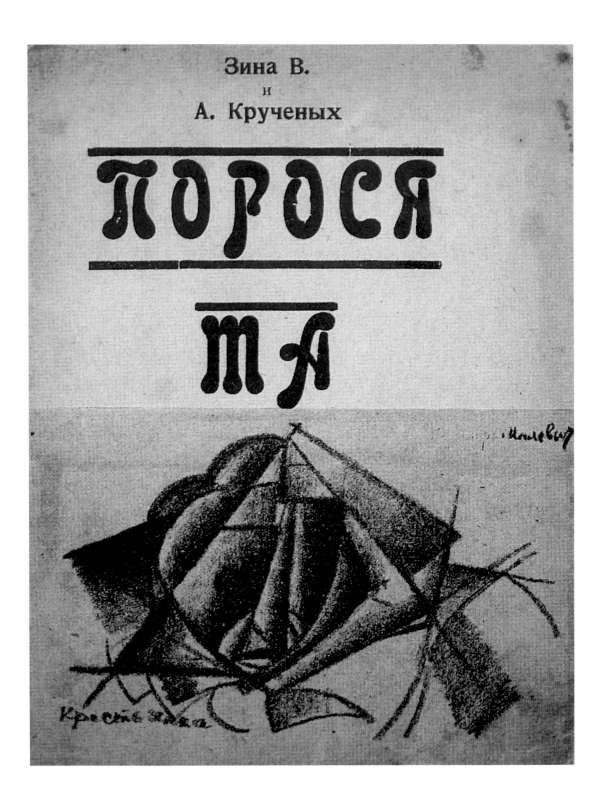

Zina V. and Alexei
Kruchenykh
Piglets
1913
Cover illustration by
Kazimir Malevich
The British Library

Alexei Kruchenykh
Pomade
1913
Cover illustration by
Mikhail Larionov
The British Library

Alexei Kruchenykh
Let's Grumble
1913
The British Library

Alexei Kruchenykh
Explodity
1913
Cover illustration by Nikolai
Kulbin
The British Library

Mikhail Matiushin
Painterly Musical Construction
1918
gouache on cardboard
51.4 x 63.7 cm
State Museum of Contemporary Art
The G. Costakis Collection

Mikhail Matiushin
Painterly Musical Construction
1918
oil on board
51 x 63 cm
State Museum of Contemporary Art
The G. Costakis Collection

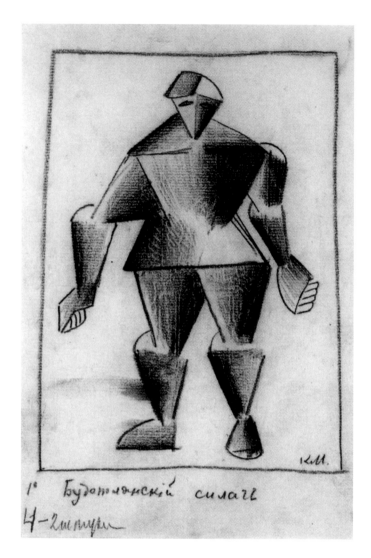

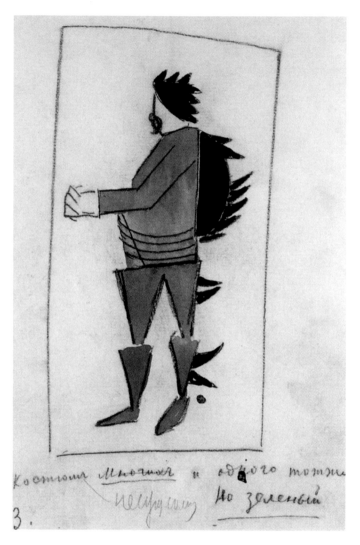

Kazimir Malevich
Futurist Strongman
from the Futurist opera *Victory over the Sun*
1913
pencil on paper
27 x 21 cm
St Petersburg State Museum of Theatre and Music (not exhibited)

Kazimir Malevich
The Many and the One
from the Futurist opera *Victory over the Sun*
1913
pencil, watercolour and ink on paper
27.1 x 21.2 cm
St Petersburg State Museum of Theatre and Music (not exhibited)

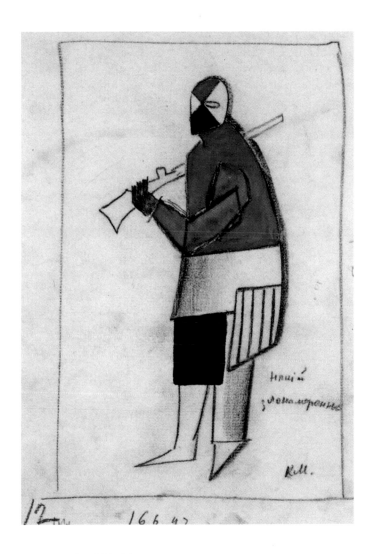

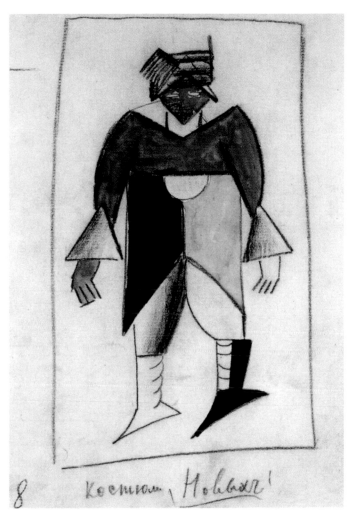

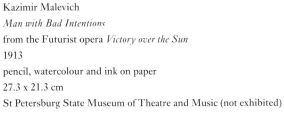

Kazimir Malevich
Man with Bad Intentions
from the Futurist opera *Victory over the Sun*
1913
pencil, watercolour and ink on paper
27.3 x 21.3 cm
St Petersburg State Museum of Theatre and Music (not exhibited)

Kazimir Malevich
New Man
from the Futurist opera *Victory over the Sun*
1913
pencil, watercolour and ink on paper
26 x 21 cm
St Petersburg State Museum of Theatre and Music (not exhibited)

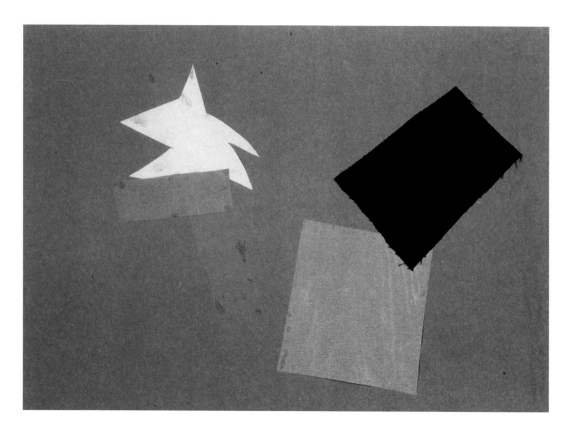

Olga Rozanova
Explosion in a Trunk
from *Universal War*, by
Olga Rozanova and Alexei
Kruchenykh
1916
paper and fabric collage on
paper
21 x 29 cm
State Museum of
Contemporary Art
The G. Costakis Collection

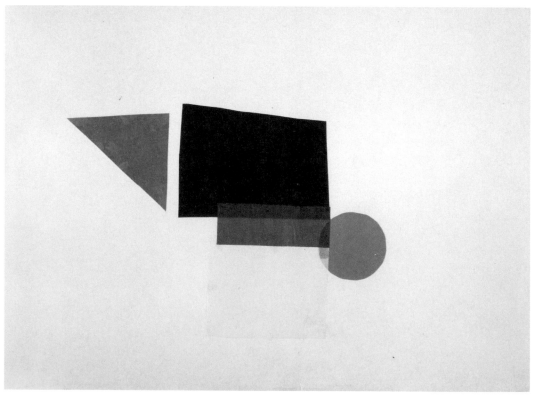

Olga Rozanova
Heavy Gun
from *Universal War*, by
Olga Rozanova and Alexei
Kruchenykh
1916
paper and fabric collage on
paper
21 x 29 cm
State Museum of
Contemporary Art
The G. Costakis Collection

Olga Rozanova
Military State
from *Universal War*, by
Olga Rozanova and Alexei
Kruchenykh
1916
paper and fabric collage on
paper
21 x 29 cm
State Museum of
Contemporary Art
The G. Costakis Collection

Olga Rozanova
*Future Man's Battle with the
Ocean*
from *Universal War*, by
Olga Rozanova and Alexei
Kruchenykh
1916
paper and fabric collage on
paper
21 x 29 cm
State Museum of
Contemporary Art
The G. Costakis Collection

Kazimir Malevich
Suprematist Composition 'Planit'
1919
pencil on paper
22 x 17.8 cm
Grosvenor Gallery

Alexander A. Vesnin
Architectonic Composition
1919
oil on canvas
70 x 55 cm
N. D. Lobanov-Rostovsky
Collection

Natalia Goncharova
Angels and Aeroplanes
from *Mystical Images of War*
1914
lithograph
32.8 x 24.7 cm
Scottish National Gallery of
Modern Art: purchased 2004

Natalia Goncharova
The Doomed City
from *Mystical Images of War*
1914
lithograph
32.8 x 24.7 cm
Scottish National Gallery of
Modern Art: purchased 2004

Natalia Goncharova
Alexander Nevsky
from *Mystical Images of War*
1914
lithograph
32.8 x 24.7 cm
Scottish National Gallery of
Modern Art: purchased 2004

Ivan Puni
Collage
1916
mixed media
25.5 x 17.2 cm
Grosvenor Gallery

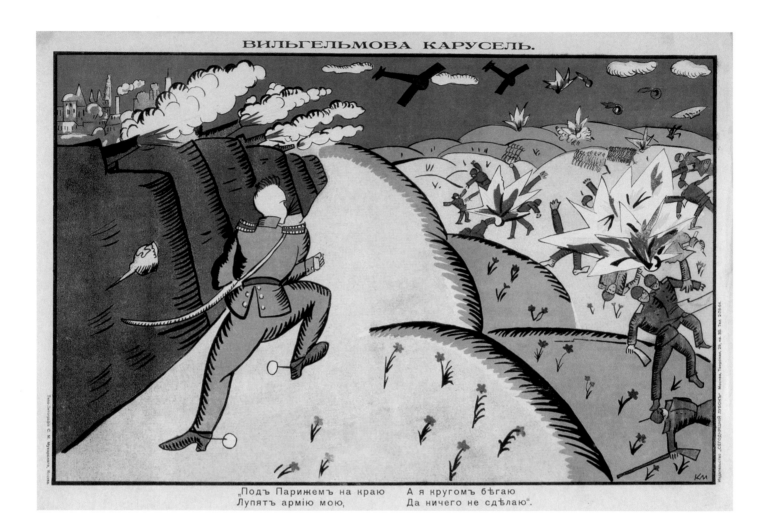

Kazimir Malevich
Wilhelm's Merry-Go-Round:
Patriotic Poster against the Germans
1914–15
lithograph
37.5 x 56 cm
State Museum of Contemporary Art
The G. Costakis Collection

Kazimir Malevich
Patriotic Poster against the Germans
1914–15
lithograph
55.9 x 37.8 cm
State Museum of Contemporary Art
The G. Costakis Collection

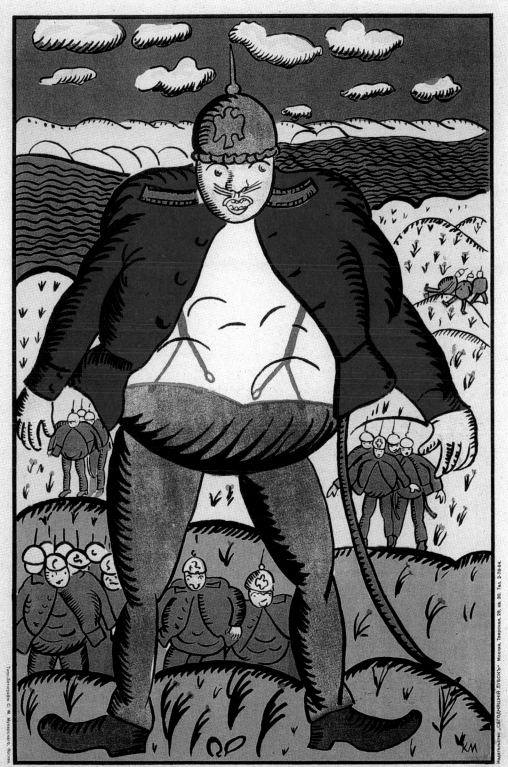

Глядь, поглядь, ужъ близко Вислы
Нѣмцевъ пучитъ, значитъ кисло!

Типо-Литографія С. М. Мукосѣева, Москва. Издательство „СЕГОДНЯШНІЙ ЛУБОКЪ" Москва, Тверская, 29, кв. 30. Тел. 2-78-84.

El Lissitzky
Tatlin Working on the Monument
to the Third International
1921–22
gouache and collage on paper
29.2 x 22.9 cm
Dessau Trust

El Lissitzky
Black Sphere
1921–22
gouache and collage on paper
22 x 16.5 cm
Private collection, London

Alexander Rodchenko
Design for a Propaganda Kiosk
1919
gouache and ink on paper
50.6 x 35.8 cm
Private collection

Varvara Stepanova
*Linear Construction
(Composition MOL)*
1920
watercolour on paper
26 x 20.5 cm
Private collection

Alexander Rodchenko
Oval Hanging Construction No.12
c.1920
Reconstruction (1972) John Milner and
Stephen Taylor
painted plywood and cord
56.5 x 84 x 51.5 cm
Collection John Milner

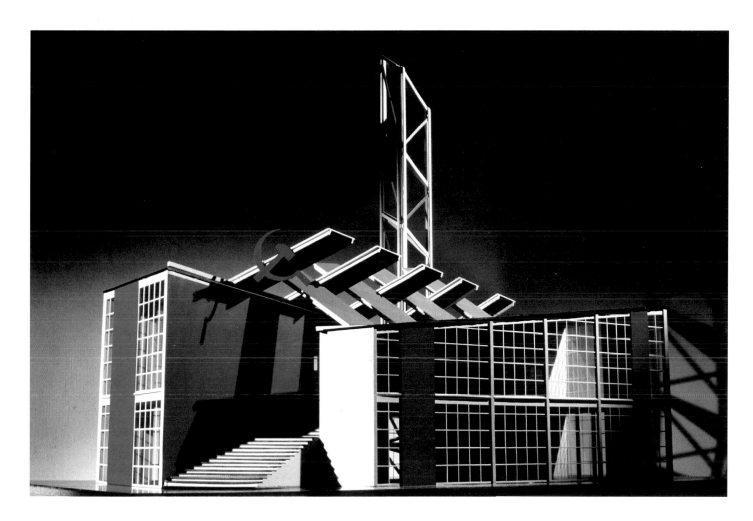

Konstantin Melnikov
Soviet Pavilion at the Paris International Exhibition of Decorative Arts
1925
Reconstruction (1994) Henry Milner
wood
96 x 192 cm
Collection John Milner

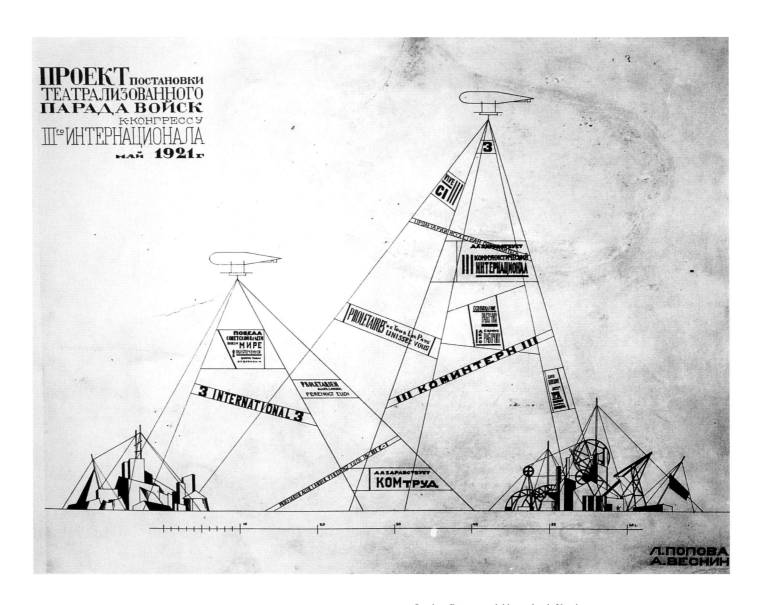

Lyubov Popova and Alexander A. Vesnin
Designs for the mass spectacle *Struggle and Victory of the Soviets*
Directed by Vsevolod Meyerhold for the Congress of the Third
International
1921
20 x 25.6 cm (above)
10.4 x 12.3 cm (opposite, above and below)
Private collection

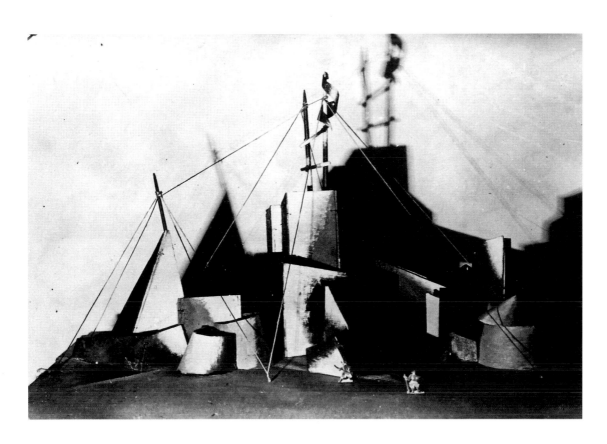

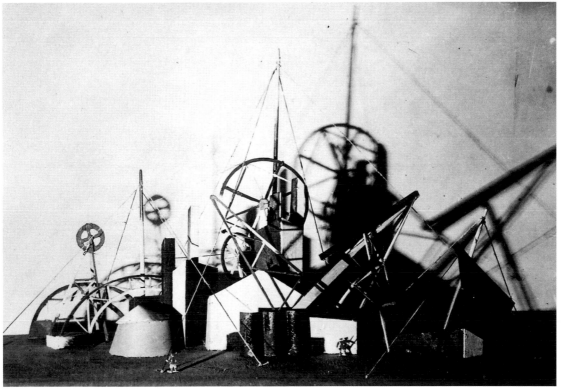

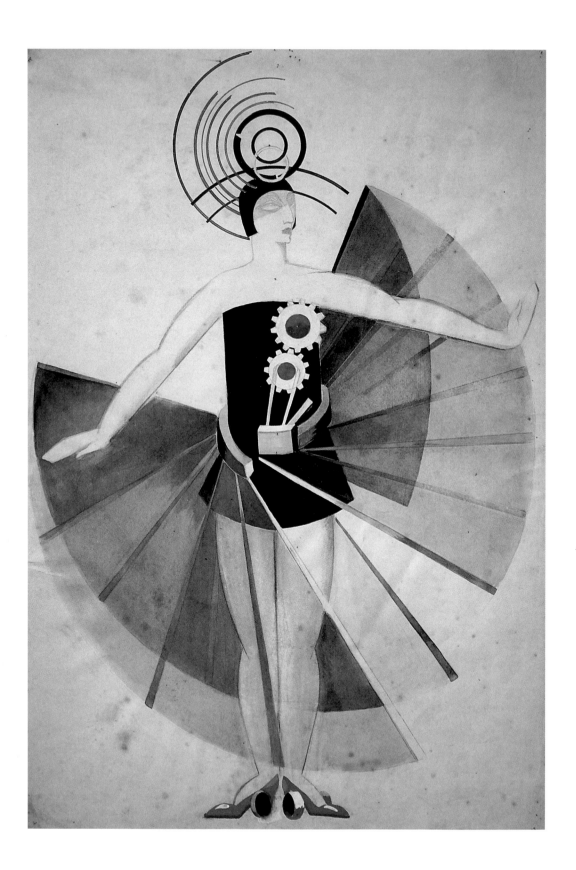

Alexandra Exter
Costume design for
the Martian from *Aelita*
1924
watercolour and gouache
on paper
53 x 36 cm
Private collection

Alexandra Exter
Tubular costume design for
the Martian from *Aelita*
1924
watercolour and
gouache on paper
56 x 40.5 cm
Private collection

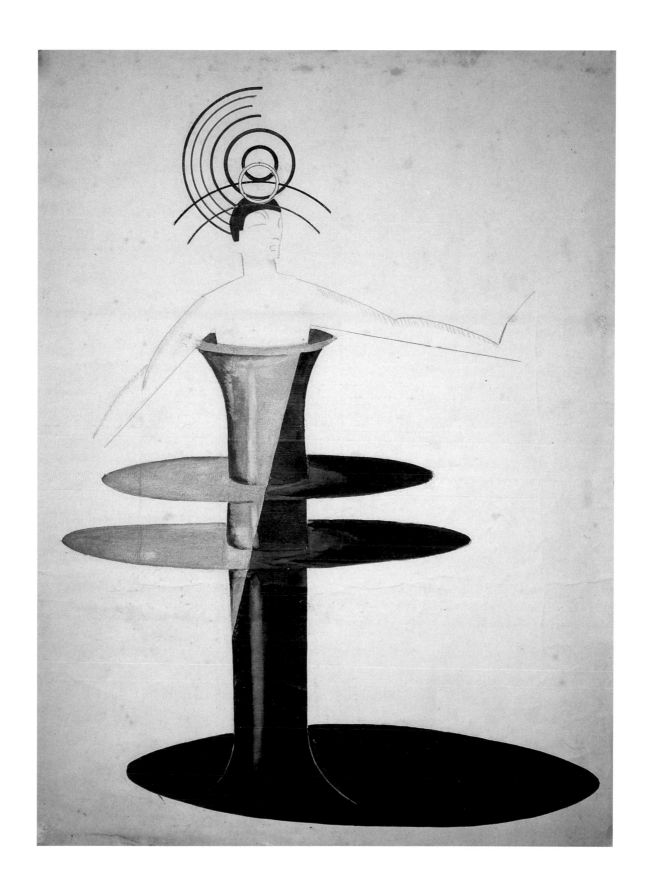

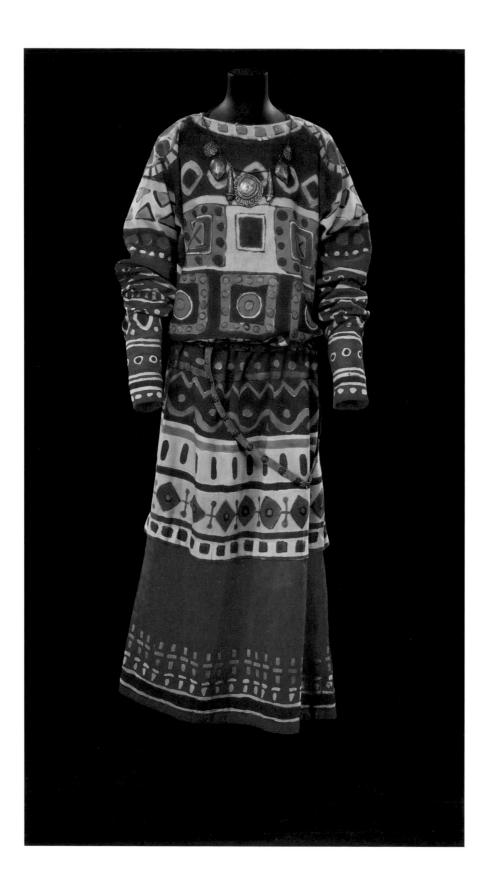

Nicolas Roerich
Costume for *The Rite of Spring*
1913
shoulder to hem: 132 cm
width: 60 cm
V&A Theatre Museum

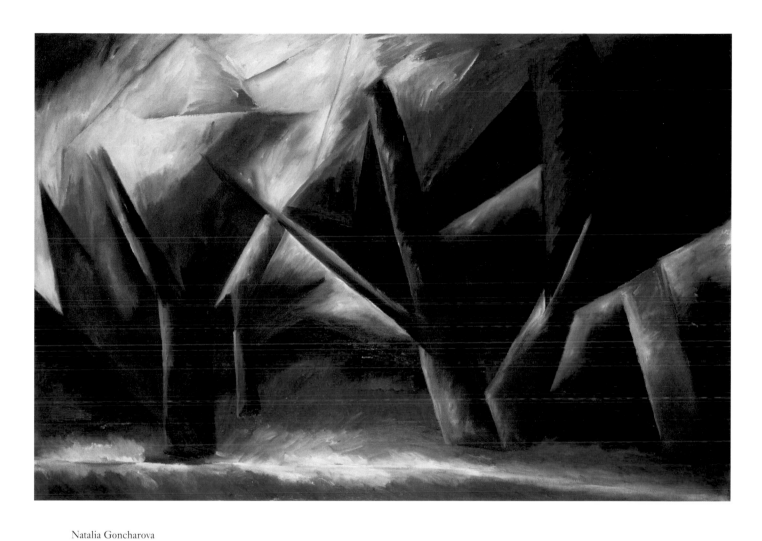

Natalia Goncharova
The Forest
c.1913
oil on canvas
53.8 x 81 cm
Scottish National Gallery of Modern Art: purchased 1977

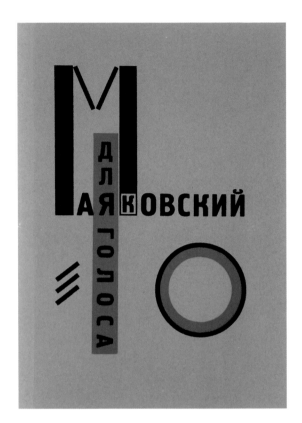

Vladimir Mayakovsky
For the Voice
1923
Designed by El Lissitzky
Victoria and Albert Museum

Alexander Rodchenko
Vladimir Mayakovsky
1924
The poet sitting on a
chair in Rodchenko's
studio in Myasnitskaya
Street
gelatin silver print
27.5 x 18.5 cm
Private collection

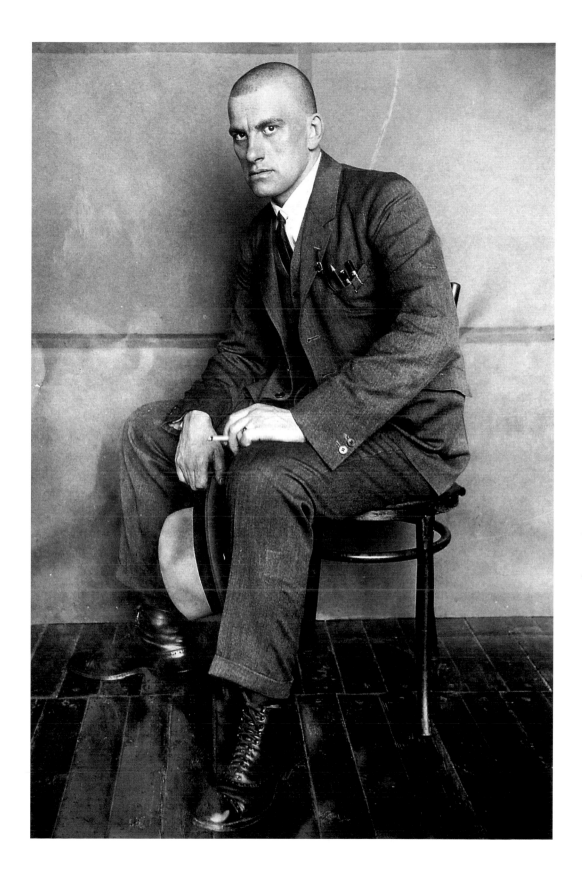

Mikhail Larionov
Costume for *Soleil de nuit*
1915
shoulder to hem: 112 cm
width: 70 cm
V&A Theatre Museum

Mikhail Larionov
Costume for a Soldier in *Chout*
1921
shoulder to hem: 124 cm
width: 86 cm
V&A Theatre Museum

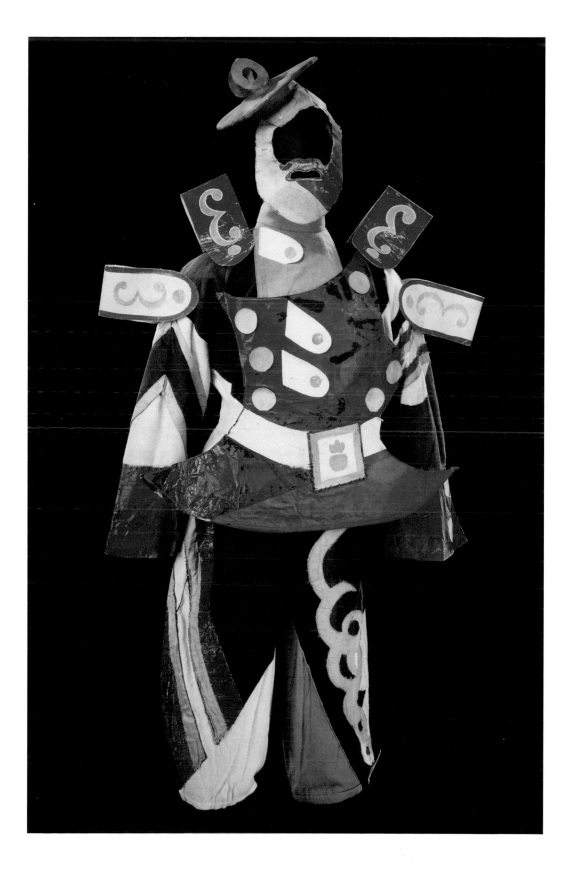

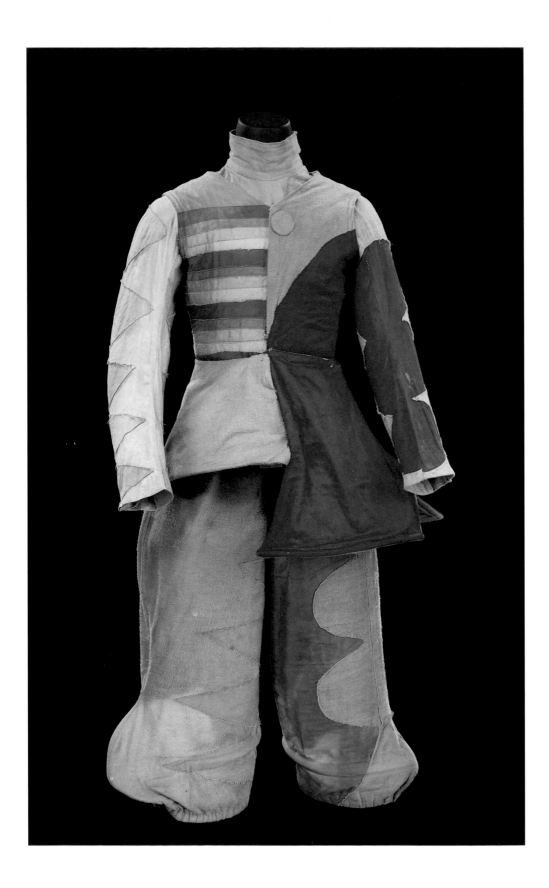

Mikhail Larionov
Costume for a Buffoon in
Chout
1921
shoulder to hem: 126 cm
width: 60 cm
V&A Theatre Museum

Mikhail Larionov
Costume for the Buffoon's
Wife in *Chout*
1921
shoulder to hem: 128 cm
width: 110 cm
V&A Theatre Museum

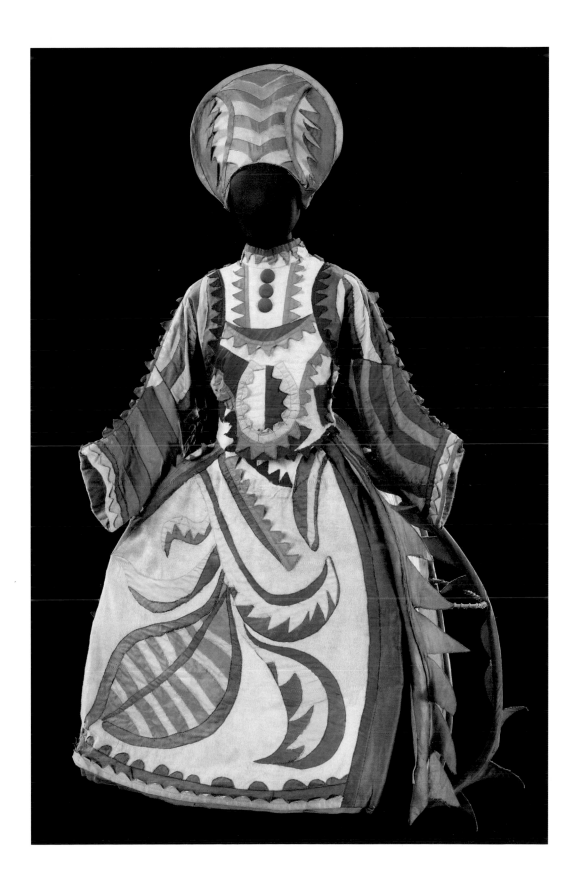

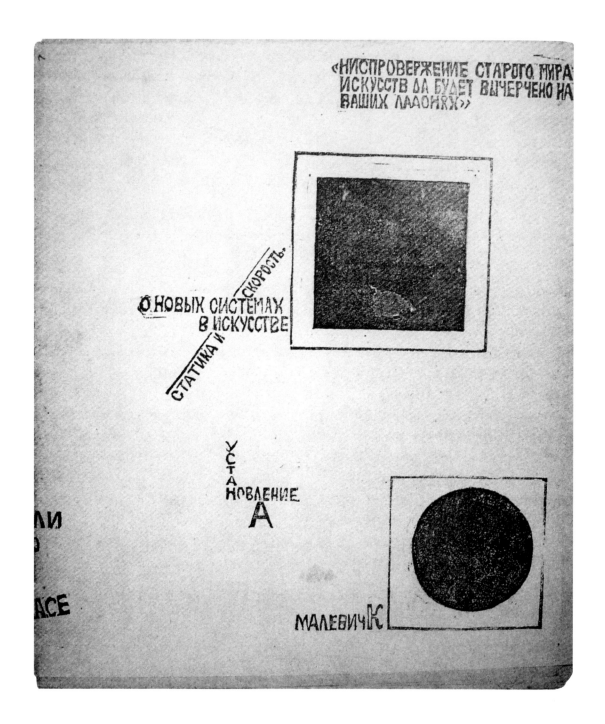

Kazimir Malevich
On New Systems in Art
1919
Cover illustration by
El Lissitzky
The British Library

El Lissitzky
New Man
from *Victory over
the Sun*
1923
lithograph
51 x 43 cm
Tate: purchased 1976

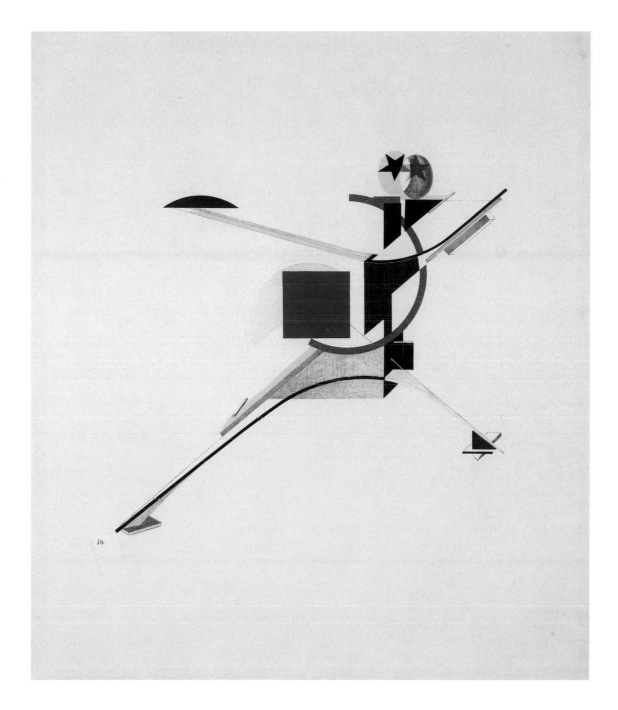

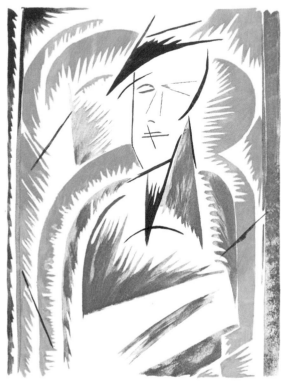

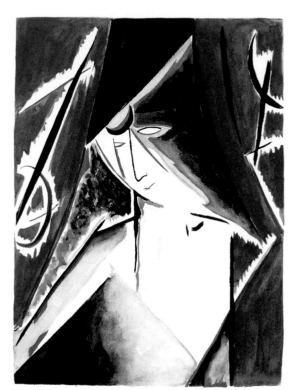

Natalia Goncharova
Theatrical Portrait
1915–16
pochoir (watercolour and gouache) on paper
16.5 x 12.7 cm
The Collection of Jon P. and Pamela J. Dorsey

Natalia Goncharova
Theatrical Portrait
1915–16
pochoir (watercolour and gouache) on paper
16.5 x 12.7 cm
The Collection of Jon P. and Pamela J. Dorsey

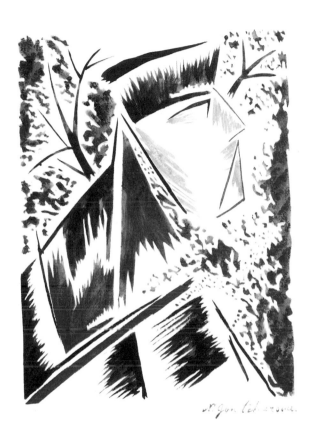

Natalia Goncharova
Theatrical Portrait
1915–16
pochoir (watercolour and gouache) on paper
16.5 x 12.7 cm
The Collection of Jon P. and Pamela J. Dorsey

Natalia Goncharova
Theatrical Portrait
1915–16
pochoir (watercolour and gouache) on paper
16.5 x 12.7 cm
The Collection of Jon P. and Pamela J. Dorsey

Varvara Stepanova
Cubist Banjo Player
1919
gouache on paper
31 x 21.5 cm
Private collection

(top left)
El Lissitzky
Drawing of 'Proun H300333'
c.1923–25
charcoal on paper
37.2 x 28 cm
Private collection

(top right)
El Lissitzky
Variant of 'Proun H300333'
c.1923–25
gouache on paper
36.5 x 26.7 cm
Private collection

(below)
El Lissitzky
Variant of 'Proun H300333'
c.1923–25
tempera on cardboard
64.5 x 60 cm
Private collection

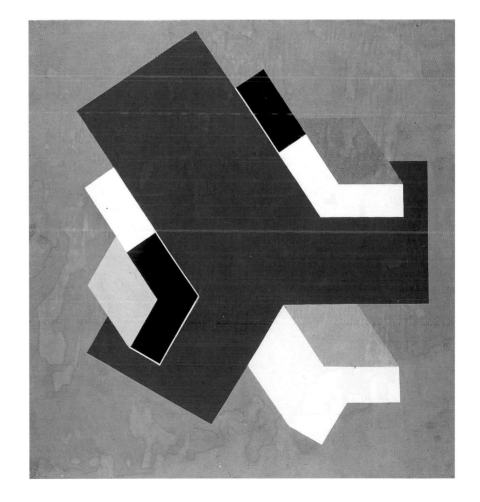

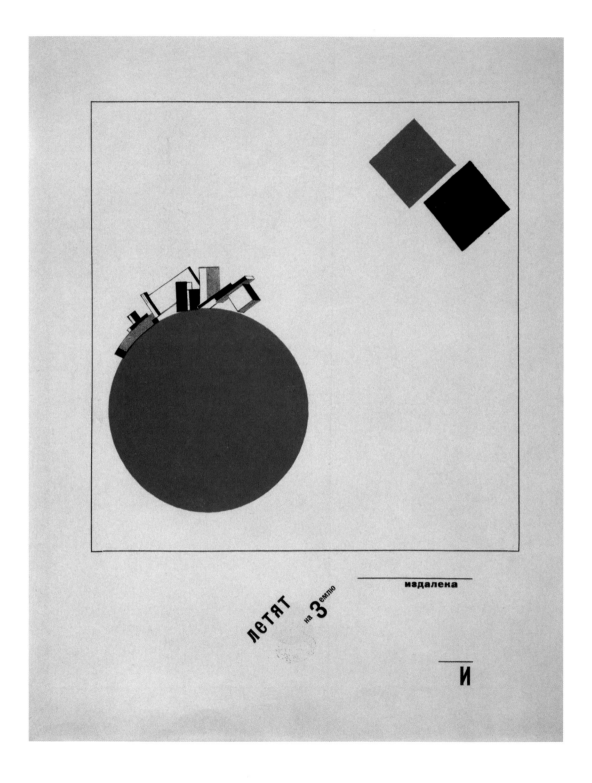

El Lissitzky
About Two Squares:
A Suprematist Tale
1922
Victoria and Albert
Museum